Mitchell Gold
+Bob Williams

Who
We
Are

ASSOULINE

Dedicated to the past
& present members of our
Mitchell Gold + Bob Williams family:

THANK YOU

for helping us make the world a more comfortable place—for everyone.

And to Bob's partner, Stephen Heavner, and Mitchell's husband, Tim Gold:

THANK YOU

for making our worlds more comfortable in so many ways.

Your love makes it all worthwhile.

Foreword

By Judith Light, actress, producer, and advocate

I dreamed of becoming an actress. The reality has been even more fulfilling than I had imagined.

You may remember me as the hardworking mom on *Who's the Boss* or the wife with a secret in *One Life to Live*. Perhaps as the matriarch on *Ugly Betty* or, more recently, for the honor of having received two back-to-back Tony Awards for *Other Desert Cities* and *The Assembled Parties*.

These opportunities, and the accompanying recognition, have been truly rewarding. However, early in my career, and actually long before I could have been called a "celebrity," I realized that what was really important to me was being in the world in a way that I was giving back. Success has actually given me an opportunity to do that.

Two and a half decades ago, my dear friends Mitchell Gold and Bob Williams clearly came to the same conclusion. They started a company that has resulted in making a lot of people more comfortable. Perhaps it's something in the DNA of some people that drives them to find ways to help others. For Mitchell and Bob, their hope in writing this book is that they may inspire more of us to craft a life that includes providing comfort. It is my hope, as well, in writing this foreword.

For me, the book recaps some of my favorite things about them. I have been a fan of their comfortable and stylish furniture from the start. I've also been a frequent guest at their dinner parties—so I was pleased to find a tasting menu, with recipes, included here.

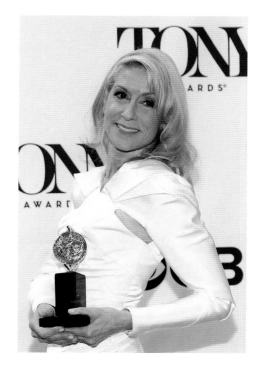

Beyond my being among their legion of "furniture groupies," our connections—and my admiration—go deeper. Both Mitchell and Bob have always supported me in my efforts to stand up for LGBT rights. And since 2006, I have been a board member of Faith in America, the nonprofit Mitchell cofounded to educate people about the harm religion-based prejudice causes the LGBT community. I have given witness to his unflagging dedication to equality for all. And I have also watched with pride as his husband, Tim Gold, develops plans for a National LGBT Museum in Washington, D.C.

My first meeting with Mitchell, however, goes back much further. We grew up together in Trenton, New Jersey, and our parents were friends. But we reconnected twenty years ago at a Human Rights Campaign dinner when Mitchell appeared next to me and said, "Our mothers will be so happy we saw each other tonight."

And while I haven't known Bob as long, I sensed he was a kindred spirit with a creativity he so generously and unpretentiously shares.

So although this is not a "how-to" book, I believe it can be considered a "how-to-live" book, one that can guide you in creating a fulfilling life of your own. It reminds me of one of their early ads: "Some people just know how to live." When it comes to Bob and Mitchell, I wholeheartedly agree.

Judith Light with her Tony Award, 2013.

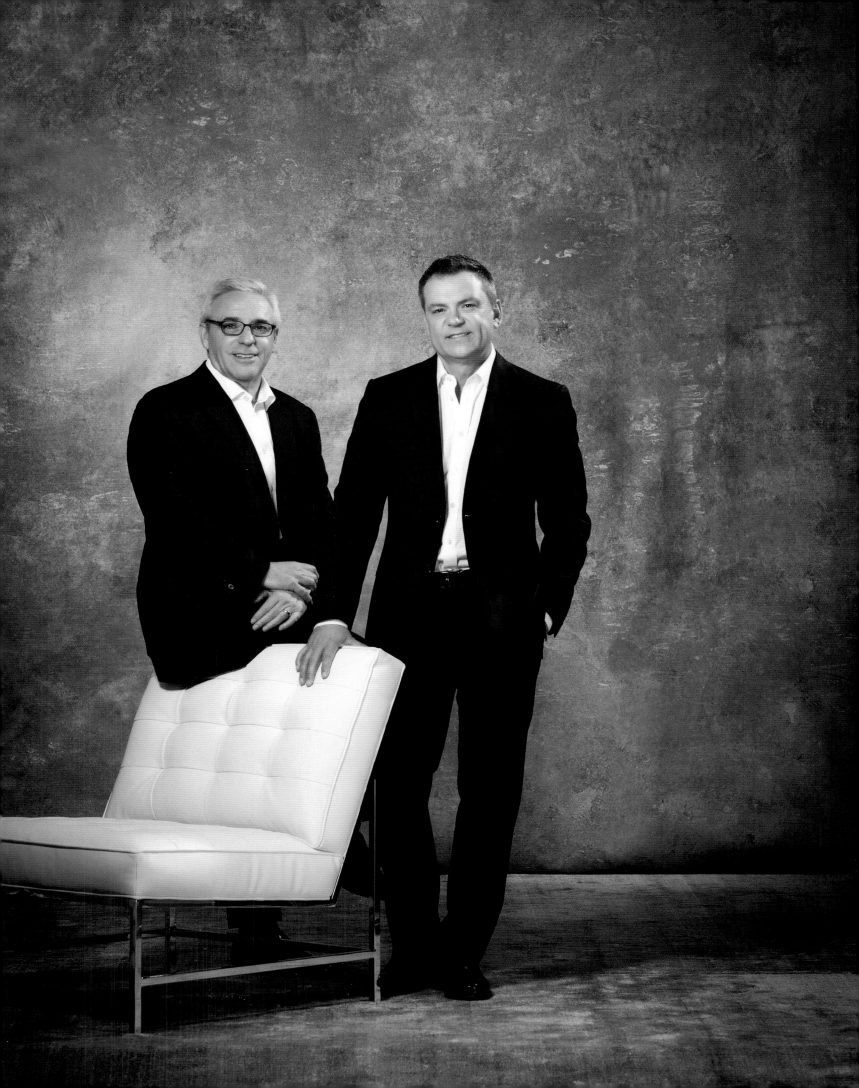

Introduction

People often ask us, to what do we attribute our success? After twenty-five years of working in tandem, we have to say it is truly the synergy we have together, both in business and in life. Finding someone who shares your aesthetics, your business views, your sense of humor, and, perhaps most important, your beliefs, has been the greatest gift.

And here's something we both passionately believe: The role of a company is not just to make money. It is also there to serve the community. Corporate greed is the last thing this world needs. And as we, and many others, continue to prove, it is not what a company needs to be profitable.

A quarter-century ago, we set out to make the world a more comfortable place. Not a single home-furnishings company was using the word "comfort" in those days. We made it paramount. We envisaged a future in which the well-designed home would be both beautiful and inviting. A haven of calm to counterbalance the hustle and bustle of everyday life. Our ethos was simple: Comfort has the power to transform lives.

So we pioneered a relaxed, modern style that quickly became our signature. Striking the perfect balance between hip and traditional, elegant and easy to live with, we captured the spirit of American design. The look married soothing colors with hand-pleasing fabrics, so a room would feel serene, never stiff. We emphasized decorating with a personal touch, letting meaningful items be the visual focus, rather than loud prints that can't be easily updated. Our soft, washable slipcovers and forgiving fabrics—some of

Mitchell Gold and Bob Williams, 2013.

our first creations—drew their inspiration from the lives of people, pets, and kids. Everything we made was expressly designed for living comfortably.

Our philosophy of comfort extended to other aspects of our business as well. We fostered a "culture of nice" and mutual respect for our customers and employees. We made every effort to be green before the term even existed in our industry. The world quickly fell in love with our responsibly made, timeless designs, and the rest, as they say, is history.

Over the years, "comfort" has grown to mean so much more to us than relaxing on one of our elegant (yet uncommonly cozy) sectionals. It's the comfort of the look, the feel, and the price. And it's also the ability to feel good about yourself. Supported and respected at your job. Safe in your home and community. Proud of the legacy you are leaving behind. Our mission is to provide comfort for everyone—in every sense of the word and for generations to come.

That mission begins at our factory and extends to everything we do. Our employee benefits include on-site day care, on-site health care, and a health-conscious café—all of which have set new standards in the furniture industry while still allowing for prices that are a recognizable value as well as sustainable profits. Our upholstered furniture is made here, in America. We have forged partnerships with local and national nonprofits working to achieve equal rights for the disenfranchised, protect women and children from harm, and research cures for life-challenging diseases.

When we started our company, in 1989, some people balked at these ideas. We were outsiders when we first settled in the small town of Taylorsville, North Carolina, two gay men transplanted from New York City. Call it naïveté or sheer optimism: We weren't afraid to question the old rules of

the "traditional furniture industry." Today, doing things differently and better remains our most valuable asset.

We believe comfort and beauty are not mutually exclusive. Our sophisticated and highly livable designs are proof positive that the two can work in harmony. We refuse to overlook the "little things" other companies ignore. Our reputation for creating high-quality products and delivering on time is unsurpassed. We invest in our workforce, our employees' children, and the greater community because it's the right thing to do. In return, our employees are loyal. Respect is a two-way street. That devotion is evident in our impeccable craftsmanship and the warm, friendly service in our stores.

Our twenty-five short years of success have taught us that it's possible to transcend the "do good or make money" dichotomy. Our impetus for writing this book was to illustrate some of the unexpected and creative ways we've found to align our goals and values. Our path has not been a straight one. But by trusting our gut responsibly and knowing when to change gears, we've paved the way for others to do things differently and better.

It was a light fixture made out of chicken wire that started it all. Bob was decorating our new home in North Carolina when the inspiration came for his first "product." Despite his having no background in furniture or interior design (in New York he'd been a magazine art director), his brilliant inventions seemed to come naturally. Mitchell, who worked on the marketing side of the furniture industry, recognized Bob's talent immediately. The idea for starting a company together was born.

When we were growing up, a good piece of furniture was something you didn't touch except a few times a year, usually during holidays. Everything needed to match, and the desired look was decidedly stiff. Bob wasn't afraid

" If this book plays even the smallest part in inspiring you to design a life filled with passion and purpose, we've done our job. **"**

to ask questions and take creative risks. He looked to fashion for ideas. In 1989 the big trend was "relaxed" fabrics: washed denim and khaki. So he asked, "Why should a sofa be scratchy?" It was an obvious question, but no one was asking it. Our first products were made from these materials and unsurprisingly were a big hit.

Everything we design is something we would want—or already have—in our own homes. We don't do a lot of market research. We trust our instincts. Think serene settings perfect for entertaining or simply curling up with a book. Graceful silhouettes that are easy on the eye and the tush. Washable slipcovers and fabrics that even kids with sticky fingers can appreciate. Blissful beds and bedding you once believed were just the stuff of dreams. Ingenious solutions to keep clutter out of sight so you can focus on the good stuff, like your dinner conversation or the beautiful view.

For us, it has always been about more than the bottom line. We have certain core beliefs that we share with many of our customers. That's why we don't keep quiet about them. We are vocal supporters of many causes and hope that, together, we can create a better future for children and preserve natural resources for them to enjoy.

We hope our insights and ideas will inspire you to make comfort a priority, both at home and in the world. Our wish is that you too have all the elements of a fulfilling life, one in which you truly live comfortably and help others do so as well. If this book plays even the smallest part in inspiring you to design a life filled with passion and purpose, we've done our job. Perhaps you'll be inspired by our "Who We Are" statement—the twenty-five mantras upon which this book is based—to create some mantras of your own. By reading them one after the other, we believe, you'll get a sense of what matters most in our lives. Then ask yourself this: What matters most in yours?

We provide

comfort.

For everyone.

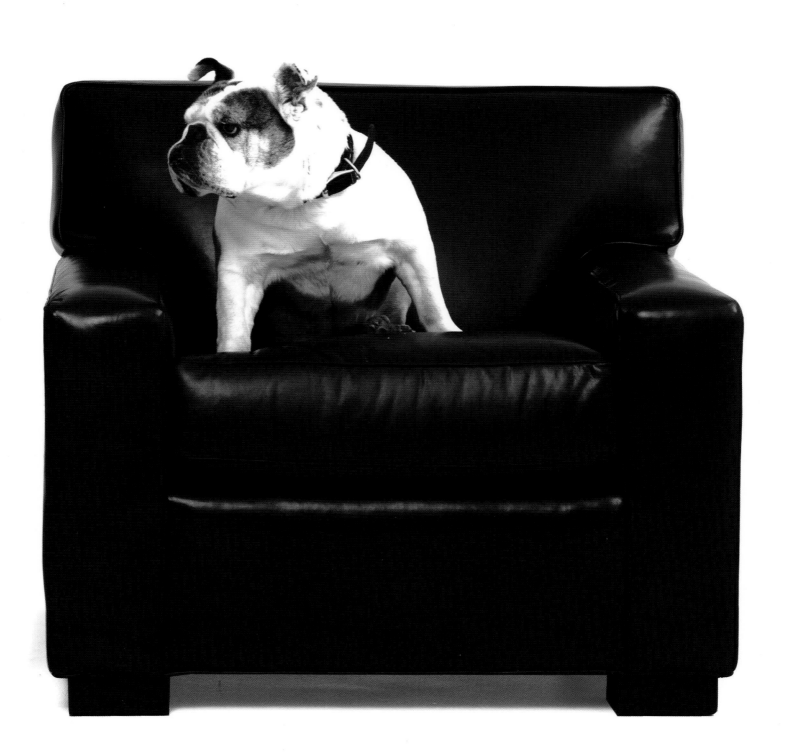

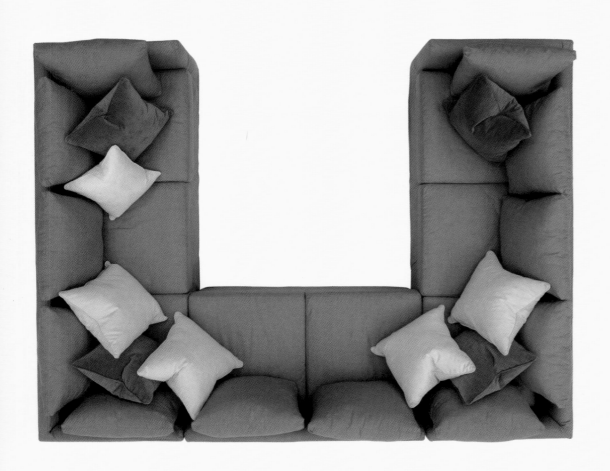

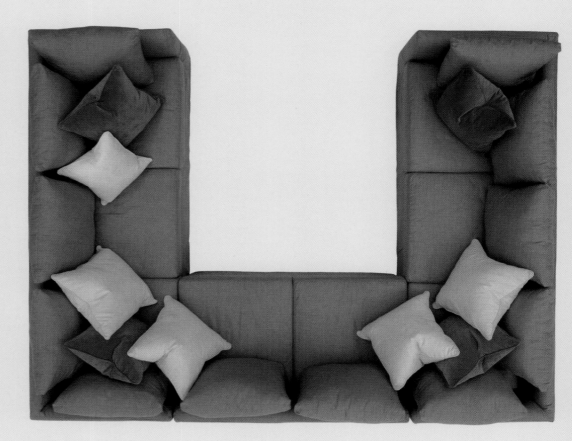
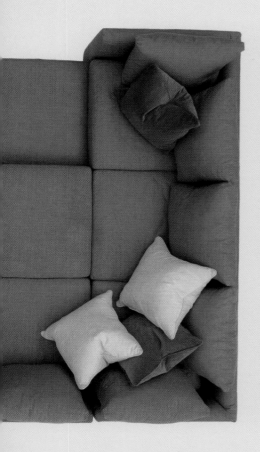
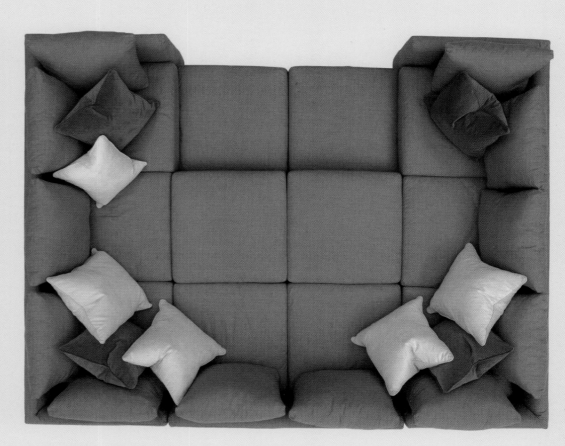

"[Comfort is] not just about whether a chair feels good to sit in. It's about being comfortable in all aspects of your life."

When we entered the home-furnishings industry a quarter-century ago, not a single company was talking about comfort. We set out to prove that beautiful design could also be incredibly comfortable. The concept was a hit with our customers and has since earned us countless awards and accolades from the design world.

From the beginning, the word "comfort" has had broader implications for us. It's not just about whether a chair feels good to sit in. It's about being comfortable in all aspects of your life—in your job, your community, and your own skin. We spent much of our childhoods feeling uncomfortable because we are gay. The harmful effects of that experience can never be forgotten, which is why we've dedicated our lives to making people feel as comfortable as possible.

We want future generations to be comfortable, so we produce our eco-friendly upholstery under the guidelines of the Sustainable Furnishings Council. We want our employees to be comfortable, so we offer benefits like our health-conscious chef-run café and a concierge service to assist with errands. We want kids to be comfortable, so we design furniture that can handle the occasional unwashed hand or pair of little shoes—and we are fierce advocates of efforts to end bullying in schools, at home, and in religious institutions. We also want our customers to be comfortable, so we create timeless furniture and accessories designed to make a house a home, and beautiful retail environments designed to be as serene and relaxing as possible. And one more thing: Our prices have to evoke a comfortable grin when a customer looks at them.

Page 17: Lulu, our English bulldog and company mascot, on the Luc leather chair. *Previous pages:* The many configurations of our Dr. Pitt sectional. *Following pages:* Dominique slipcovered sofa with our Tribute to Music print above it. *Pages 24–25:* 2001 ad campaign: Why Do Cowboys Love Mitchell Gold?

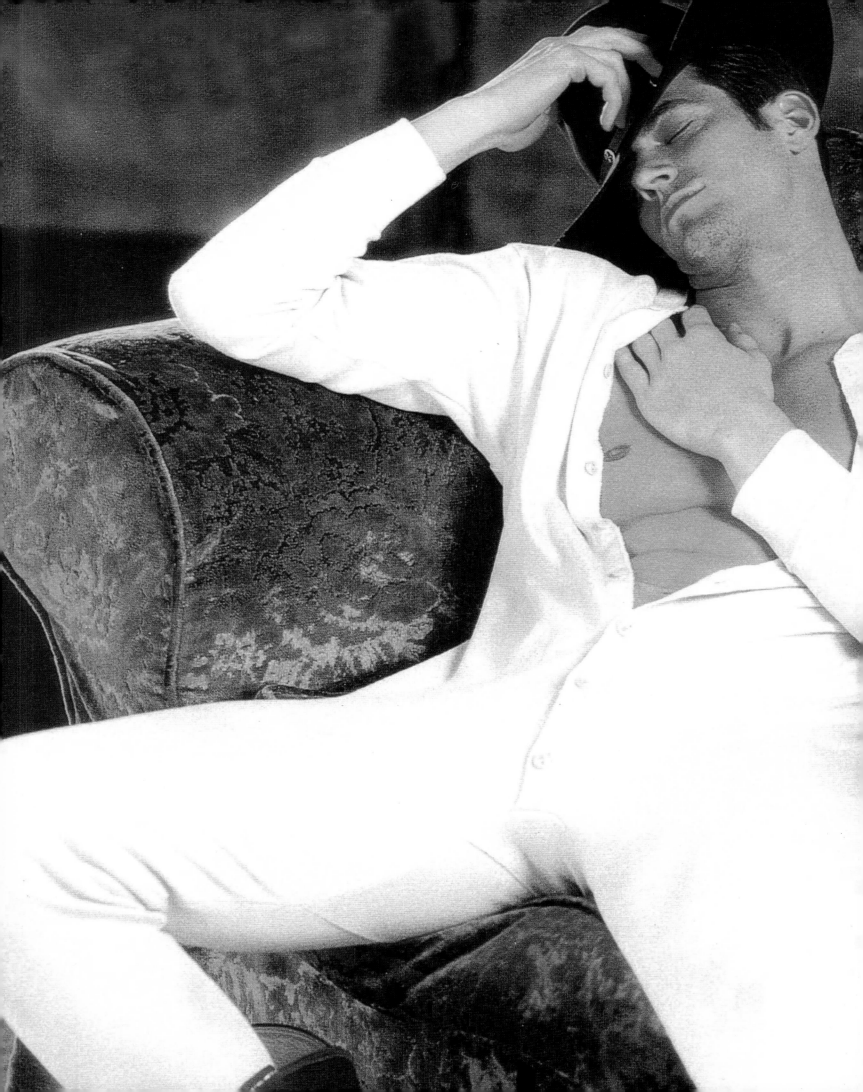

We were once a jewel of a company 23 people strong and growing. We are now a jewel of a company

600+

people strong and growing.

In 1989 we began producing upholstery in the small North Carolina town of Taylorsville. Our office was in our home. The business grew so quickly that it soon took over every room in the house. So what did we do? We bought a cow field with a double-wide trailer in the middle of it and moved our office there. We didn't last long in that field, but it was there that we devised a long-term future for our company.

We decided not to build a separate office, but to integrate one into the factory. That would grant us greater control and oversight of the manufacturing process. If there was a problem with the way a button was being attached, we could simply walk over to the sewing department and find the best way to fix it. This decision was one of the best we ever made—it's the reason we've made consistently high-quality products for twenty-five years.

In 1997 we moved to a 600,000-square-foot state-of-the-art factory just a few miles down the road. We are the largest employer

Opposite: With Lulu, circa 1998. *Following pages:* The 1997 groundbreaking ceremony for our state-of-the-art factory. We designed the factory and offices to be in one building for a sense of connection throughout the manufacturing process. Bob designed the house façade surrounding the front door to make it feel more like home.

in the county. Some of the biggest chains in the country have carried our products for years, including Bloomingdale's. Dozens of the best boutique retailers nationwide also feature our pieces. We have opened Mitchell Gold + Bob Williams Signature Stores in many major North American cities. This year we will open several more.

None of this would be possible without the talent and dedication of our employees. It's their hard work that keeps this place running every day, and their spirit permeates everything we make and do.

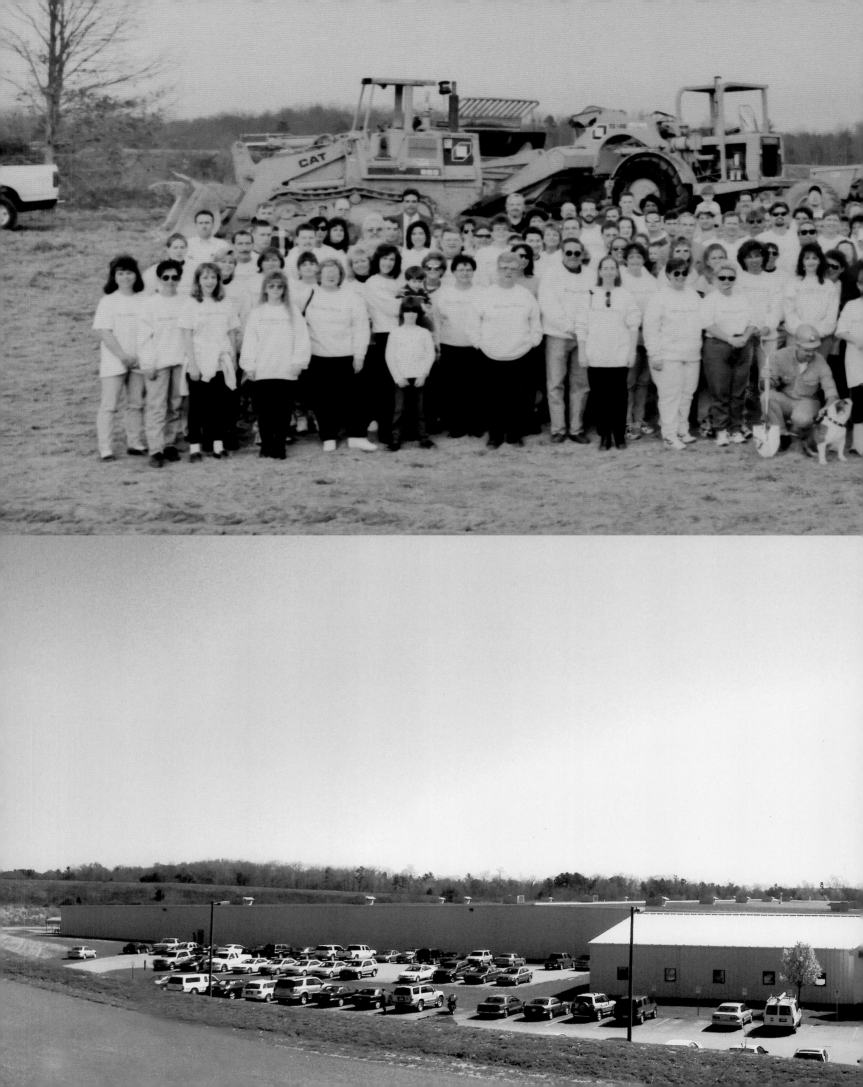

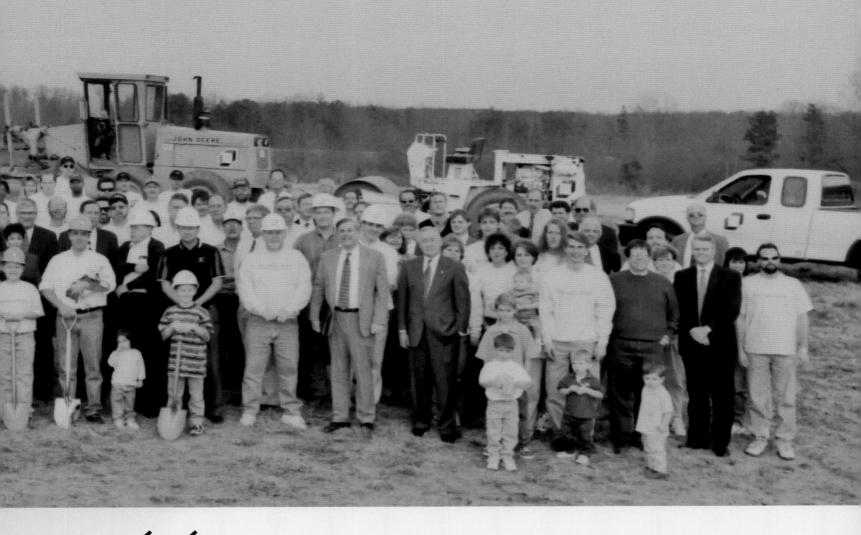

“ None of this would be possible without the talent and dedication of our employees. ”

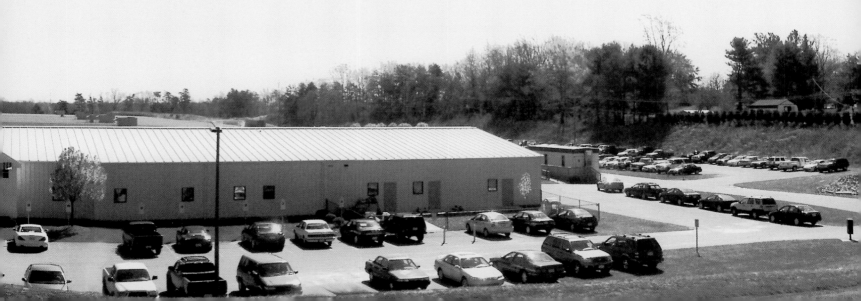

We are forward *in thinking* and *design.*

What is the shape of things to come? This is the question we ask ourselves before designing every collection. We consider not only how people live today but also how they will live—and dream of living—in the future.

New homes are a great indicator of shifting tastes and lifestyles. Years ago, we saw that homes were being built with smaller, less formal dining rooms, eliminating the need for bulky breakfront cabinets. Recognizing that this meant a loss of storage and serving space, we began to rethink the dining experience. A console or sideboard could help with both, as well as be a platform for keepsakes and photos, or the perfect place to drop your mail and keys. It could also offer a range of appealing decorative looks, depending on what you topped it with—a mirror flanked by sconces, a collection of art. The epiphany for us was that a single piece of furniture could perform all these functions—and it didn't have to "match." Rearranged later or moved into a different home, the right piece could work just as easily in an entryway or a living room.

We created the Trinity sectional to offer varying depths, depending on where you sit, so that it would be comfortable for people of different sizes.

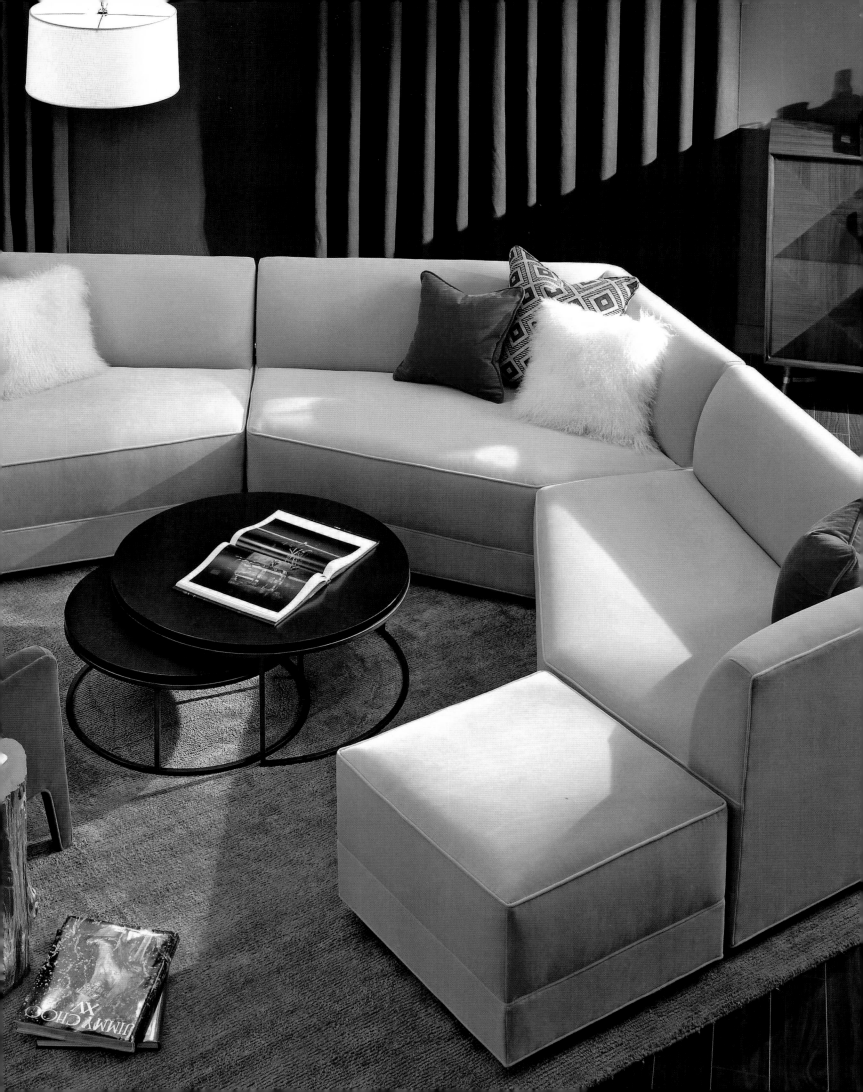

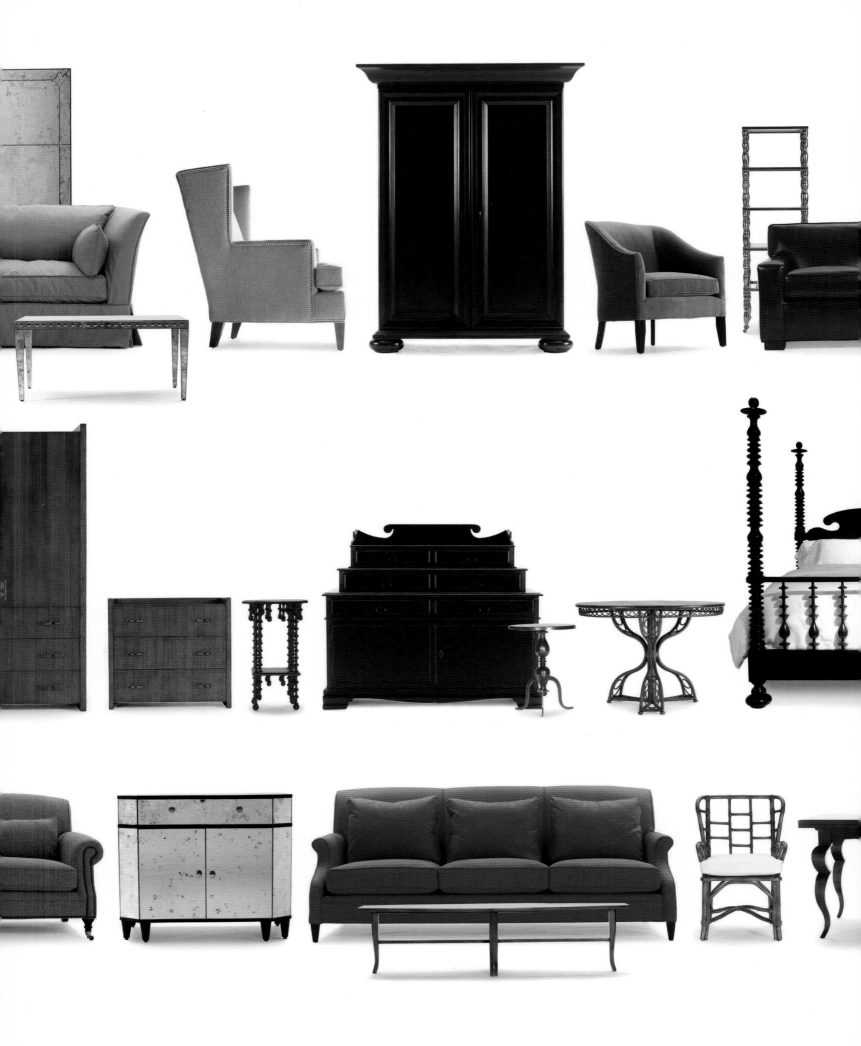

We also look at where young people are living: revamped industrial lofts, reconfigured mid-century ranch houses, tiny studio apartments. Their creative use of space never ceases to inspire us. We designed our low Fritz bookcases to artfully encircle the clean lines of one of our modern sofas, maximizing storage and reducing visual clutter. And we're always looking for furnishings that can do two things at once: Our versatile nesting tables make great end tables, with extra serving surfaces when needed. Our upholstered ottomans are designed as extra seating or serving space for guests, as well as great places to put your feet up when relaxing solo. (We call them "comfortable cocktail tables" because they feel so good—and because no one will tell you to get your feet off the table.) We also use the power of luxurious accents, from soft shag to cool metallics, that take their cue from the architecture of our favorite periods but are reinterpreted to reflect a current sensibility.

The everyday needs of a modern family are cause alone for innovation. We put a lot of thought into what will make life easier. Sometimes it's as simple as providing the right options. For instance, in addition to being offered with a glass top, our Parsons dining tables are available in a choice of wood tops, so families with young children don't have to worry about lingering fingerprints. Or take something like our Trinity sectional. It is truly the shape of things to come: With only three pieces, you can create unique configurations to suit a space, and even change a configuration to suit an occasion. This striking seating also provides exceptional comfort for all shapes and sizes, thanks to its variations in seating depth: Lounge where it's deeper, sit up straight where it's less so. It's the perfect marriage of sophistication and relaxed functionality, designed with tomorrow in mind.

Our first collection of case goods (industry-speak for tables, chests, and cabinets), launched in 2005, had a modern and traditional feeling. *Following pages:* We love a mix of iconic styles from modern eras in fabrics as diverse as menswear tweed, faux suede, and vinyl (seen on the ottoman)—with such a great feel that we call it vinelle.

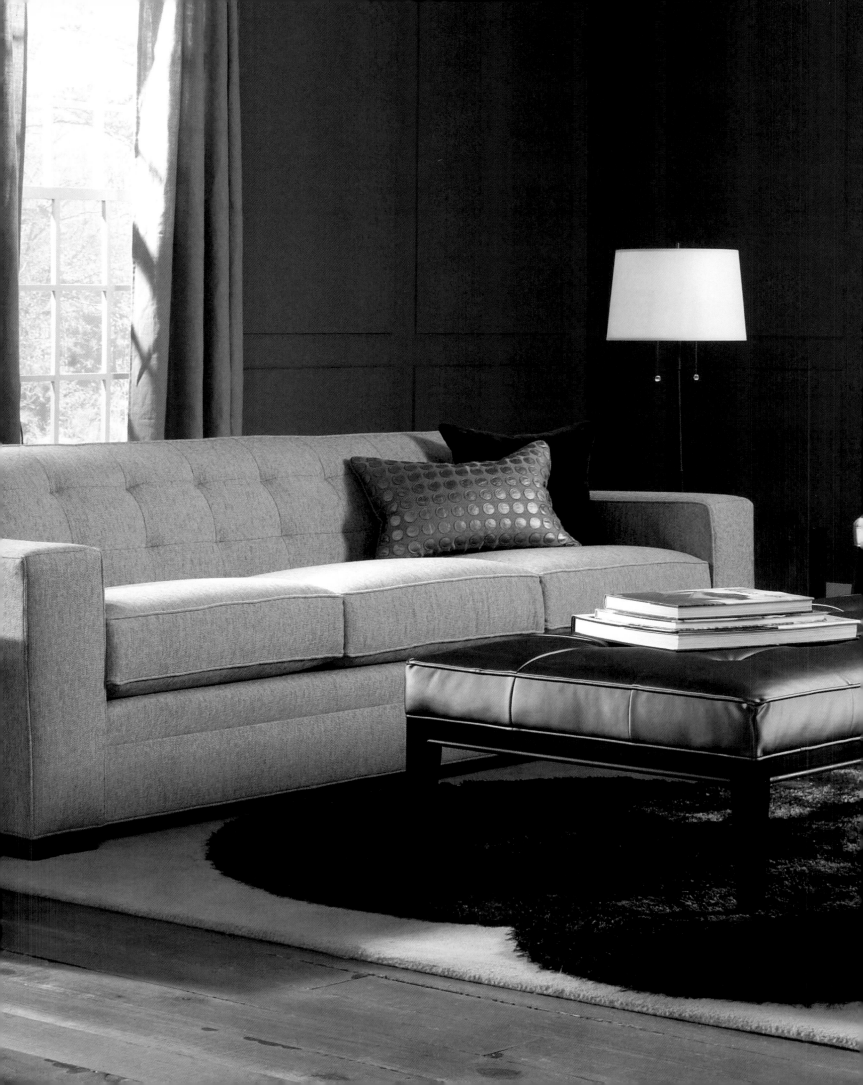

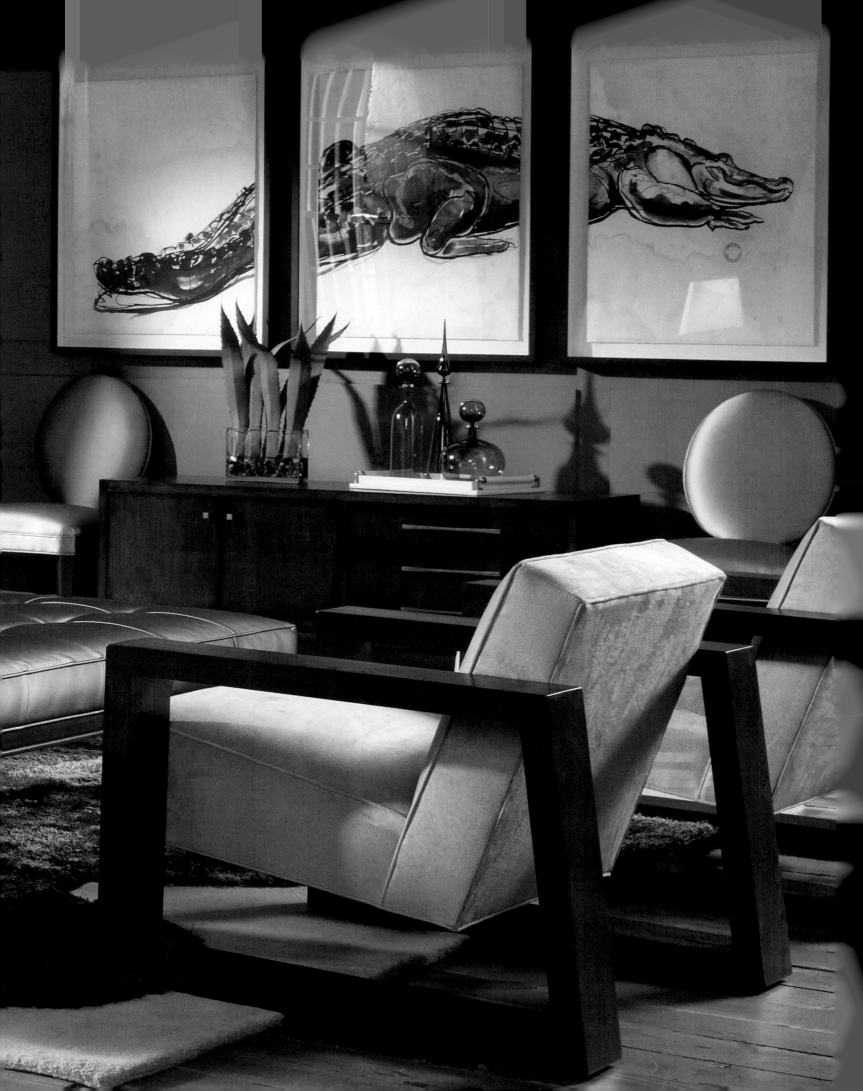

We look BACKWARD to LEARN.

From the biggest antique and flea markets around the world to the small screen of our iPad minis, we scour all avenues of the past, looking at furniture to inspire our new collections. How was something done? How can it be done today? How can the colors be used in a more interesting, appealing, and better way?

We love history. We marvel at designs from the past. As times and manufacturing techniques have changed, however, we have the luxury of combining the best of what was with the newest and most efficient. Now we can make things far more cost-effectively, bringing our collections to a wider audience.

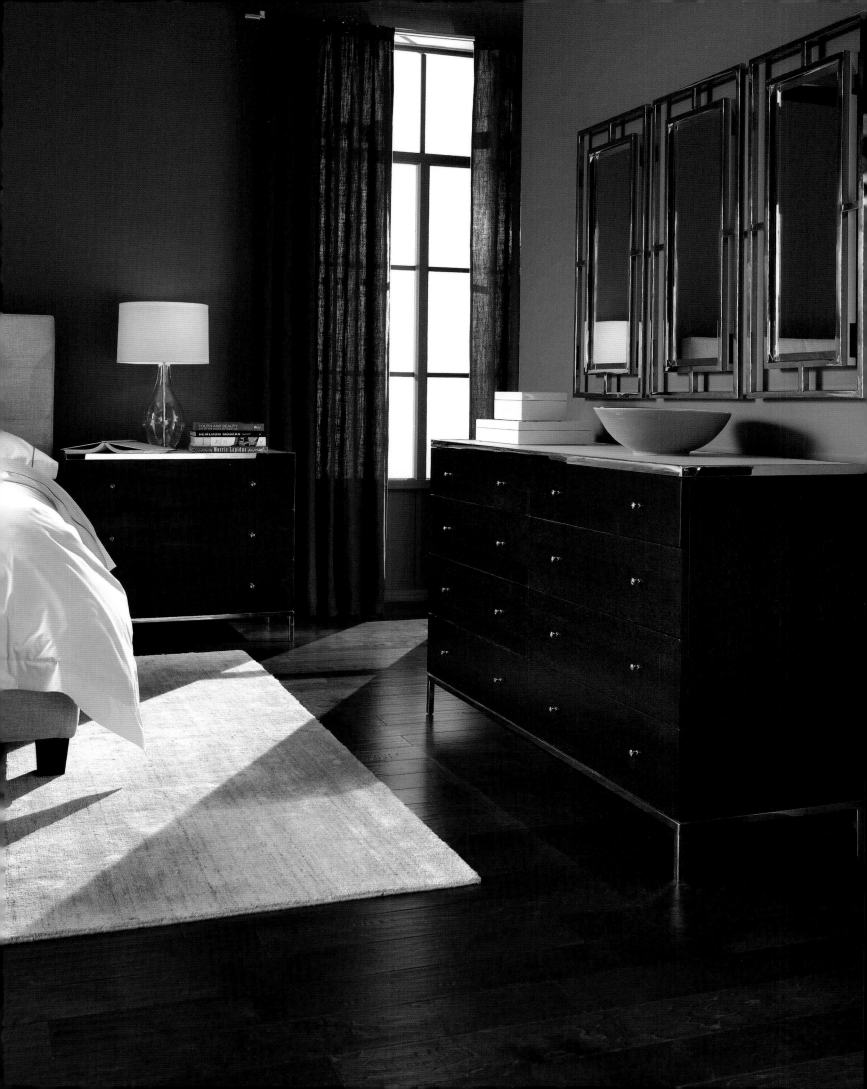

Today our collections are greatly influenced by designers we respect from the latter half of the past century. The 1950s, 1960s, and 1970s were rich with modern lines—new clean and easy ways of living that mirrored the era's rapid technological innovations, yet softened the accompanying hustle of an increasingly fast-paced life.

We also look to history to learn how to make our lives better. Throughout history, religious teachings have been used to justify many kinds of atrocious discrimination, most notably slavery. People of color, as well as women, minority religious groups, and interracial couples fighting for equal rights, have been thwarted by political and religious leaders who used theological doctrine to falsely validate their denial of justice and equality for all. History has shown how wrong those leaders were.

That same tactic is being used today against lesbian, gay, bisexual, and transgender (LGBT) Americans. In 2005 we founded Faith in America, a national nonprofit organization dedicated to addressing religion-based bigotry. We believe this is the key to achieving both equal legal rights and spiritual peace. Unfortunately, many American teens remain subject to horrible pain and suffering today. Gay teenagers who are rejected by their families on religious grounds are too often driven to drugs, alcohol, and homelessness. Suicide rates are four times higher among LGBT youth.

The mission of Faith in America is to educate the public about these unnecessary and horrific consequences, and facilitate dialogue in the hope of protecting future generations from harm.

Our message is simple: History does not have to repeat itself in mean actions. In beautiful furniture? Yes, it can.

Here's history we're working to stop from repeating: using religious teaching to justify discrimination.
Previous page: Inspired by iconic mid-century modern design, our Manning chests are a more dressed-up version of modern, thanks to a sexy mix of caviar-stained ash, white glass, and stainless steel.

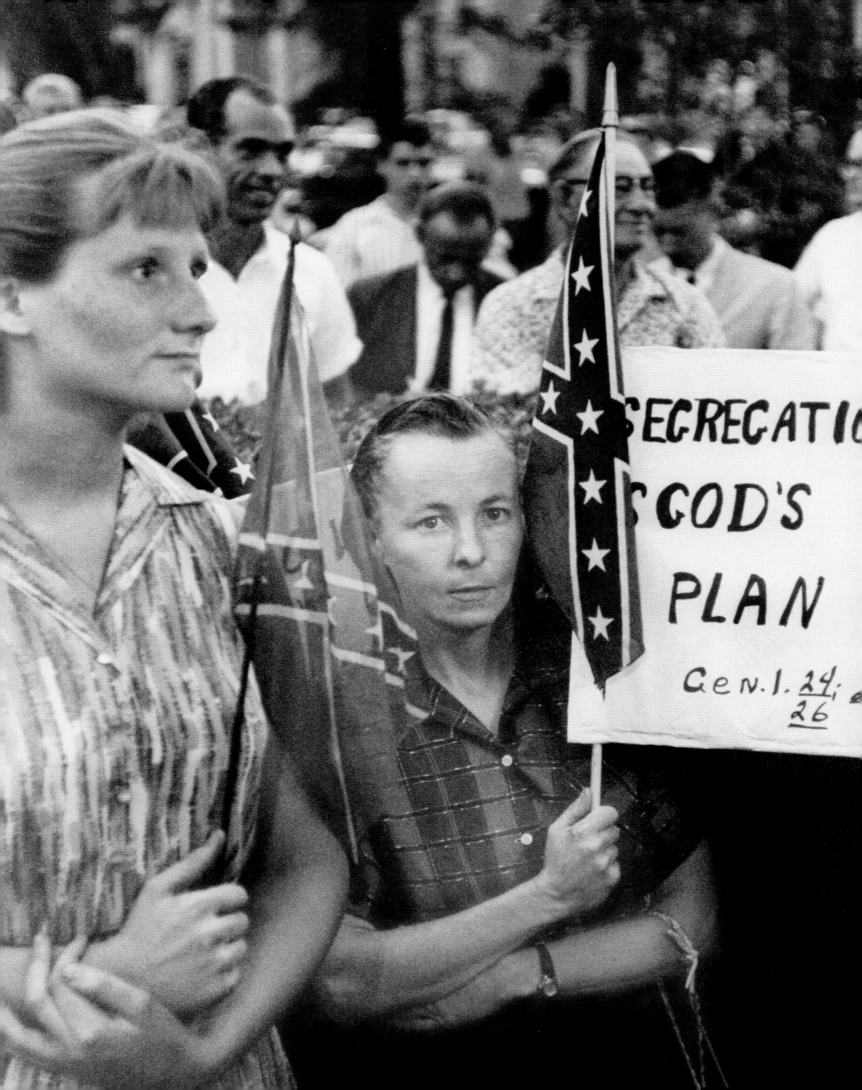

We create
our upholstery
in **AMERICA**.
We create
jobs for
our economy.

For more than a century, North Carolina has been at the heart of America's fine-furnishings industry. For the past twenty-five years, we've created all our upholstery here, in the small town of Taylorsville.

The region's rich heritage is on display every day at our factory. Talented local artisans use skills passed down for generations. In an age when few things are still made in the United States, we are proud to keep the area's furniture-making tradition alive.

Locating our headquarters in North Carolina has also been good for business. The proximity offers us maximum oversight, so quality issues don't slip through the cracks. We can monitor our employees' working conditions, because they're the same as our own. And being here, in America, makes it possible to consistently ship on time.

Fabrics inspected, tagged, and ready for upholstering—this is key to our ability to manufacture quickly and ship on time. *Opposite:* Many of our employees come from families that have been crafting furniture for generations. *Previous pages:* From a 2011 ad celebrating the skilled artisans who make our upholstery in the small town of Taylorsville, North Carolina, USA.

We provide consistently **good quality.** We deliver consistently **on time.**

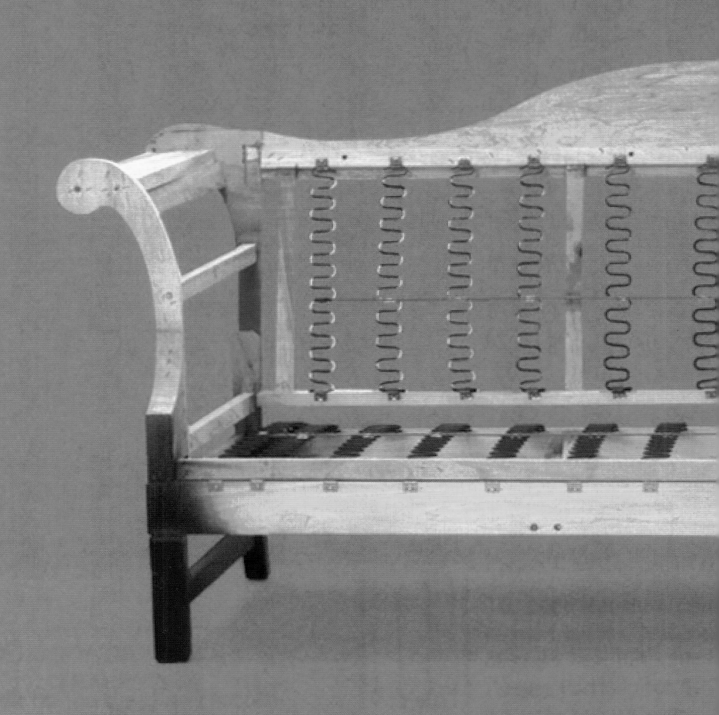

Hanging from the ceiling of our factory are signs that read, "Consistently GOOD QUALITY. Consistently ON TIME." Garrett Barr, our senior vice president of manufacturing, will tell you that even the signs regularly get cleaned. Our quest for perfection is apparent in everything we do, from our many quality-control checks to simply keeping the factory clean. These are details many companies overlook. Perhaps we are just more curious than most, but looking the other way has never been our strong suit.

We are adamant about providing consistently good products and always shipping on time. That requires two things: operational excellence and experienced, loyal employees. A company cannot run efficiently if "little things" are neglected, so we pride ourselves on paying vendors on time and keeping appointments on time, so they will ship to us on time. We attract exceptional talent by paying fair wages and offering benefits like on-site day care, health care, and a great place to eat breakfast and lunch. That we have so many long-term employees is a testament to the success of these programs.

When a sofa or chair or table arrives at your door, we make it all look easy. But there's a lot of hard work behind each speedy, on-time delivery. Every part of that process was considered, down to the last detail. The result? Virtually no returns and lasting customer satisfaction.

We'll do anything to get your furniture to you on time! This photograph was taken for *New York Cottages & Gardens*, "Special Delivery," April 2012. *Previous pages:* Buying upholstery is in some ways similar to buying a car—knowing what's "under the hood" helps you understand the quality. *Following pages:* Portraits of manufacturing team members.

We are UN-PRE-DIC-TA-BLE.

We have never been afraid to push boundaries. And in few places is that more apparent than our advertising and new-product introductions. A handsome young male model is surrounded by babies on a sectional. "We're Coming Out" announces the debut of our sleep sofa on a pink background. A gay couple relaxes at home with their daughter under the banner "A kid deserves to feel at home."

All of these were unprecedented marketing ideas at the time. We like to think our advertisements helped shape public opinion about gay marriage and modern families. They also managed to sell a lot of furniture.

One advantage of owning your own company, at least at the beginning, is that if you want to take a risk, the only person you have to answer to is yourself. Early on, we looked to other industries to inspire our ads and products—fashion, in particular. We decided to make our furniture look as sexy as possible. We also made sure to place our ads in just the right publications to make a punch. And all that was a big part of the fun—and our success. As we've often said, it's not just advertising that makes people remember a brand—it's the right advertising.

Yes, we once were head-over-heels for cottage style: Mary Jo, in a multi-floral slipcover. *Following pages:* As many of you know, shirtless male models are hard for us to resist. Here's one in our 2010 ad featuring our Cara swivel chair: The Modern Movement.

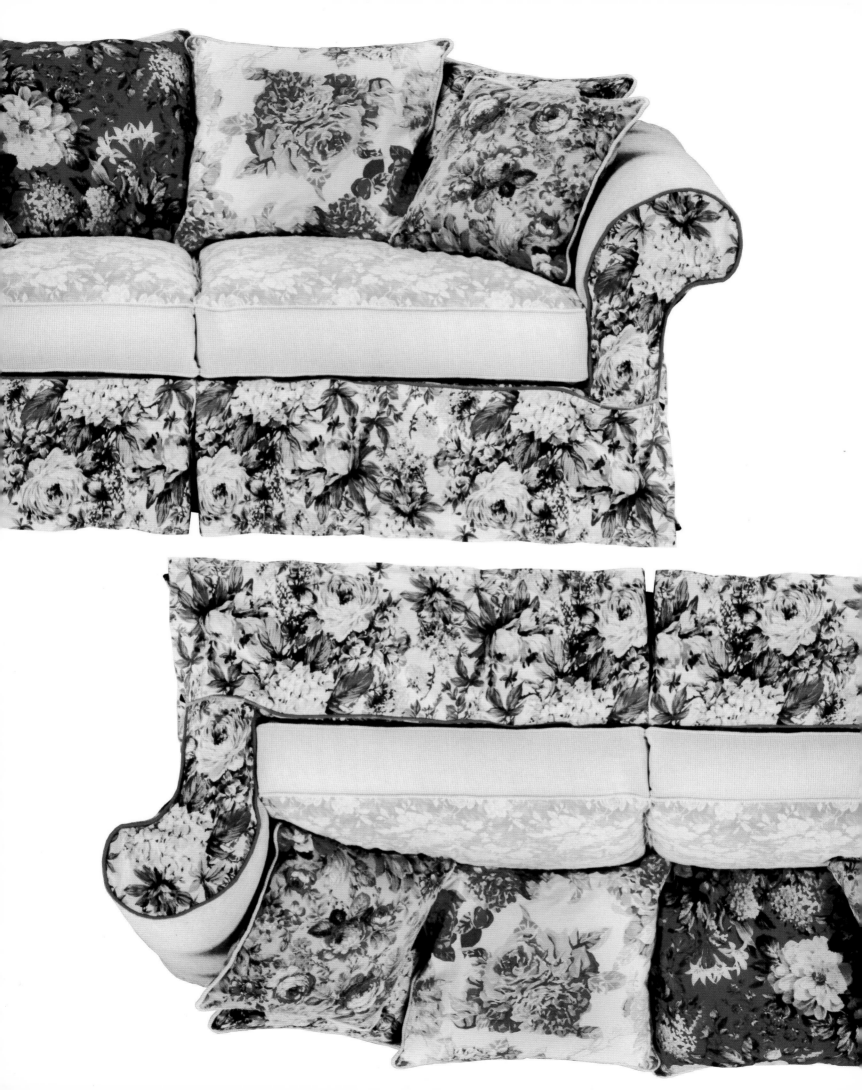

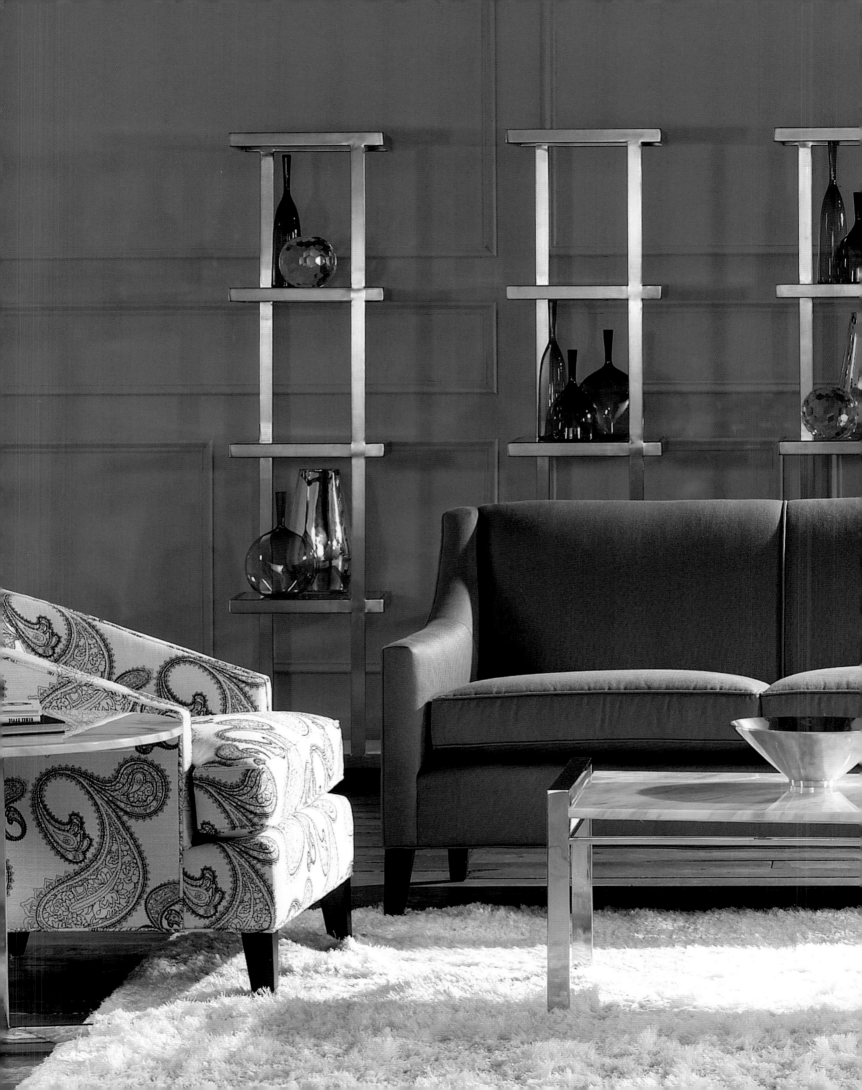

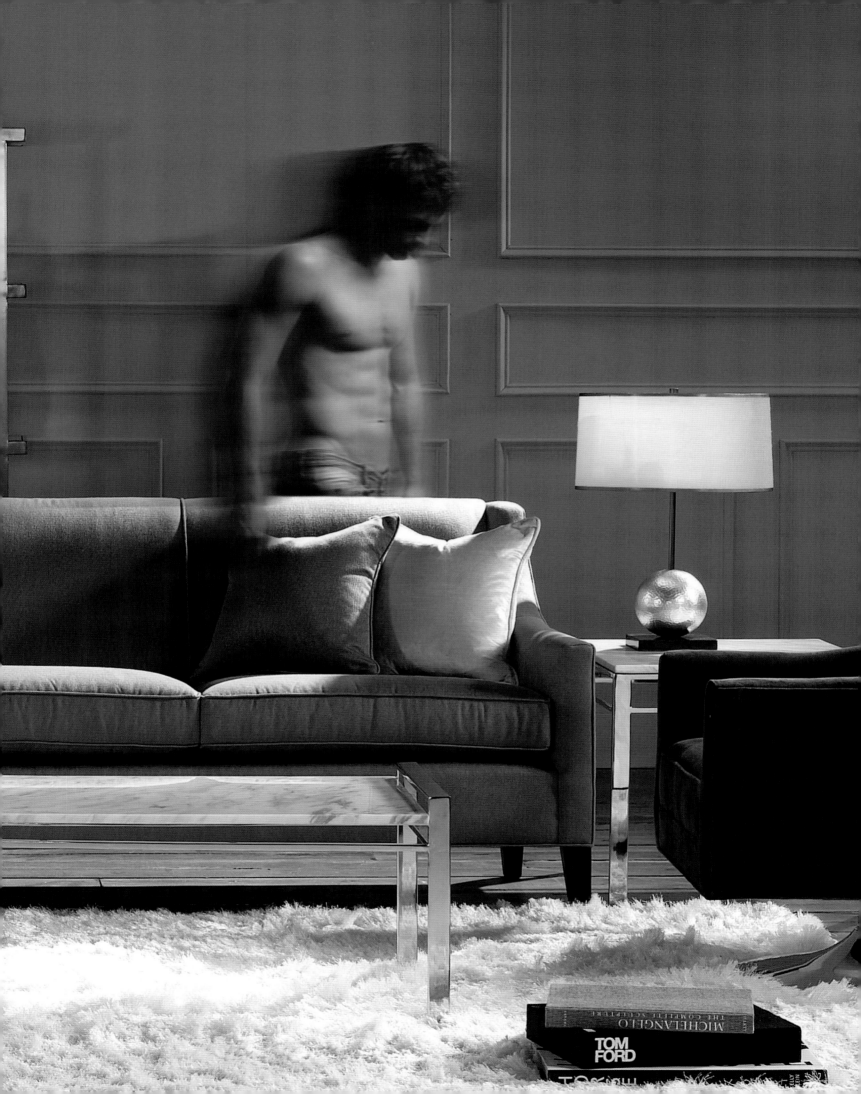

> **"** We couldn't have predicted how unpredictable we'd be. Who knew we'd put ten fabrics on a sofa or devote ads to a profile of our dog or a guy in leather pants standing on a leather chair? Or sit in a goofy chair in Vermont? **"**

Mitchell at a Restoration Hardware company meeting. Our "chair-man" never passes up the chance to check out a classic. *Following pages, from left:* A 2002 ad: Love Mitchell Gold. Leather.; Lulu with a chair charm based on a piece from the 2000 Platinum collection.

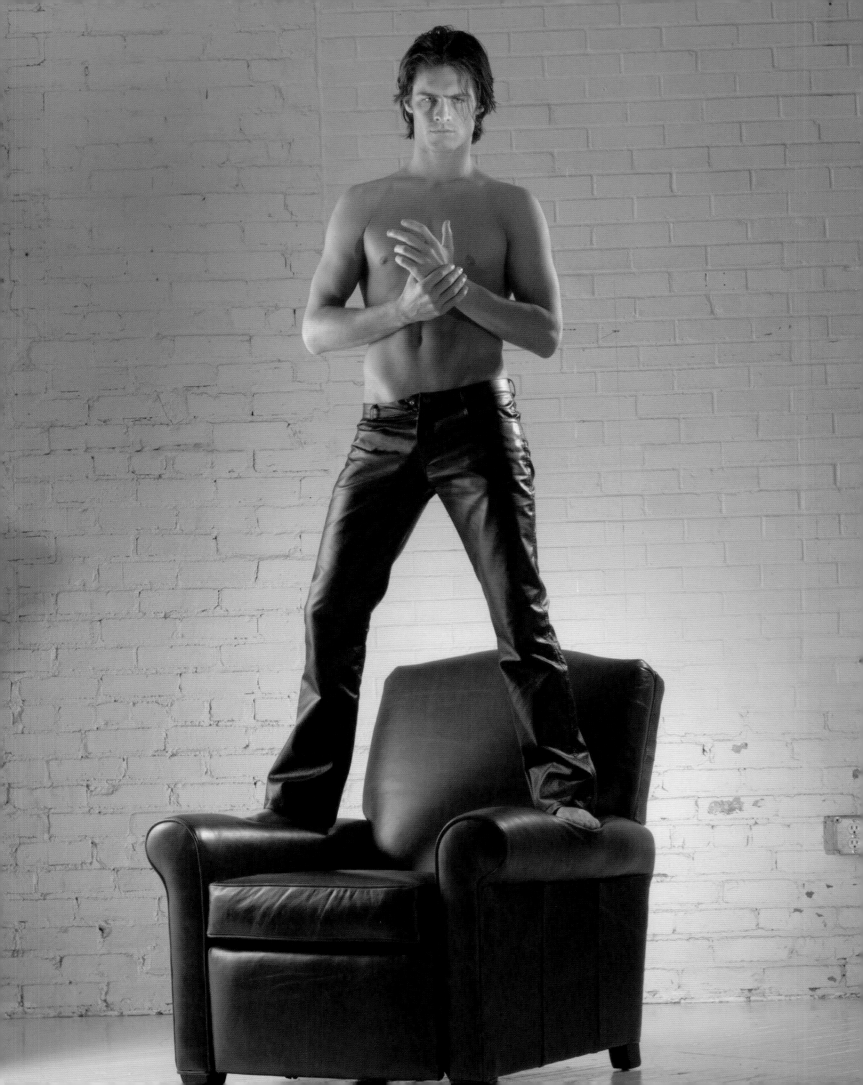

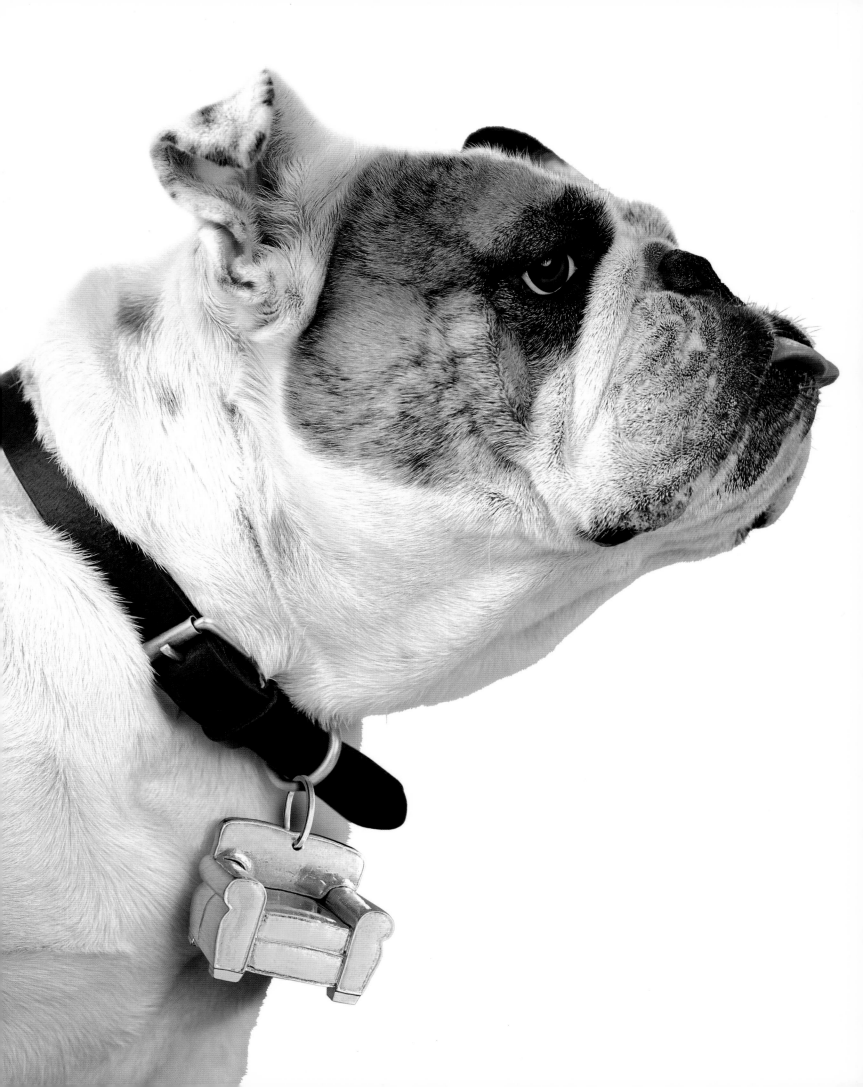

we love to laugh.

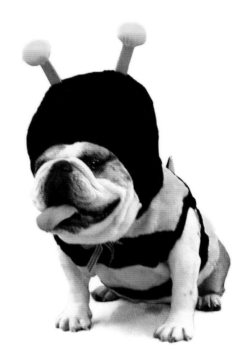

As our employees, friends, and out-of-town guests know well: We love a funny story, and we love to laugh. For example, one of the goofy things we do is put new executives on the spot at their first meeting with a group and ask them to tell a funny story or joke. It's surprising how some have risen to the occasion. With recent M.B.A. in hand, our national sales manager, Katie French, seemed pretty demure and very sophisticated. Then she told a couple of jokes that had us in tears. It's a great way to break into a new crowd.

Many years ago, we were in Italy visiting one of our most innovative tanneries, the folks who brought us one of our first, incredibly successful leathers that had a vintage look from the get-go. In short order we were doing millions of dollars of business with them. After we spent the day at the tannery, Franco, the owner, invited us to dinner with his parents, his wife and young children, and his brother and sister and their families. Around a big table, we ate a fantastic meal—every course included asparagus because it was asparagus season—with never-ending wine. As dinner drew to a close,

Lulu in one of her earliest Halloween costumes. *Opposite:* At the entrance to our day-care center with the adorable triplets, Austin, Makenzie, and Davis Merritt, who, like their older sister, Ashlyn, have gone to the day care since they were babies. Their wonderful mom, Cheri, works for us.

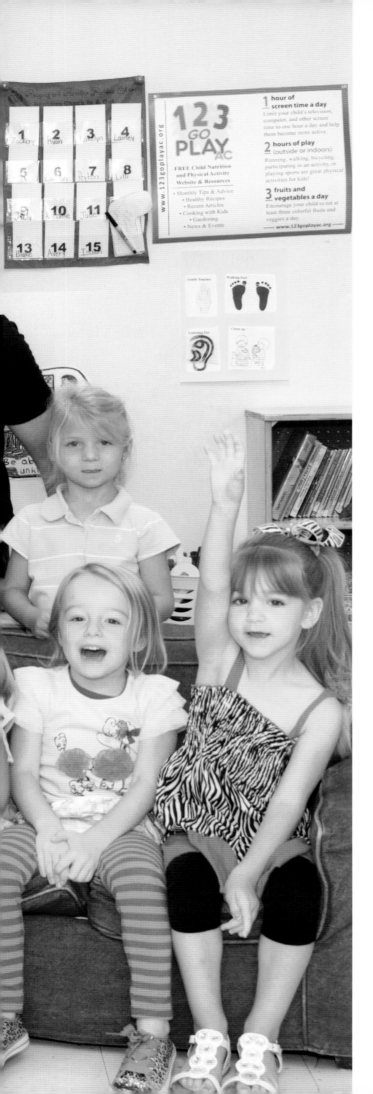

our host announced that it was time to laugh, and that he would start. At first he forced himself to laugh, but then quickly he began to laugh in earnest because he was being so silly. One by one around the table, everyone started laughing. It was contagious—and exhilarating. We'll never forget looking around the table of laughing people, from four years old to eighty, and feeling so welcomed to their family.

And much closer to home, whenever things get hectic at work, we're lucky enough to be able to walk into Lulu's Child Enrichment Center, where the beautiful children in our day care are sure to give us a smile and a laugh.

A lively group from our day care with Kim Draughn, director since the center opened in 1999.
In Mitchell's arms is Aubrey, daughter of national sales manager Katie French. Front and center with power tools is Benjamin, son of director of upholstery Laura Chapman.

We are in the **homes** of many famous people.

And we are in the homes of many more not-so-famous people.

Like a good neighbor, we respect the privacy of our clients. So we won't mention the name of every cultural luminary or political figure we've won over with our soft and modern style. Let's just say that it was fun meeting the guy who lives on Pennsylvania Avenue and hearing him say that he loves the chair he swivels and rocks in, which we made.

Helping people furnish a comfortable life is a great honor for us. Whether it is a client who has chosen us to furnish his or her whole house or a customer needing a single piece of furniture, contributing to the enjoyment of someone's everyday life is reason enough to go to work in the morning.

Many homes featuring our furnishings have graced the pages of the wonderful magazines that have raised awareness and interest in good design over the years. We mourn those that have ceased publishing—for us there is still nothing like holding a beautiful full-color magazine printed on fine stock. But we also follow with avid interest the online incarnations, and are thankful for the amazing visual voyages they take us on.

The expression of our style can also be found in our own homes. Whether city condo, suburban house, or lakeside retreat, they are our havens—and also our design labs. Rather than use focus groups to tell us what to make, we pursue comfort on the most personal level and share what works especially well with our customers.

In 2004, Mitchell was a delegate to the Democratic National Convention, and we put up billboards that said, "Send Mitchell Gold [furniture] to the White House." Our dream was to modernize the decor, and in 2008, it came true when pieces from our line were included in the Obama update of the private quarters. *Following pages:* Will's office on the set of CBS hit drama *The Good Wife,* for which we designed a custom collection in collaboration with set decorator Beth Kushnick—the first furniture license in TV history.

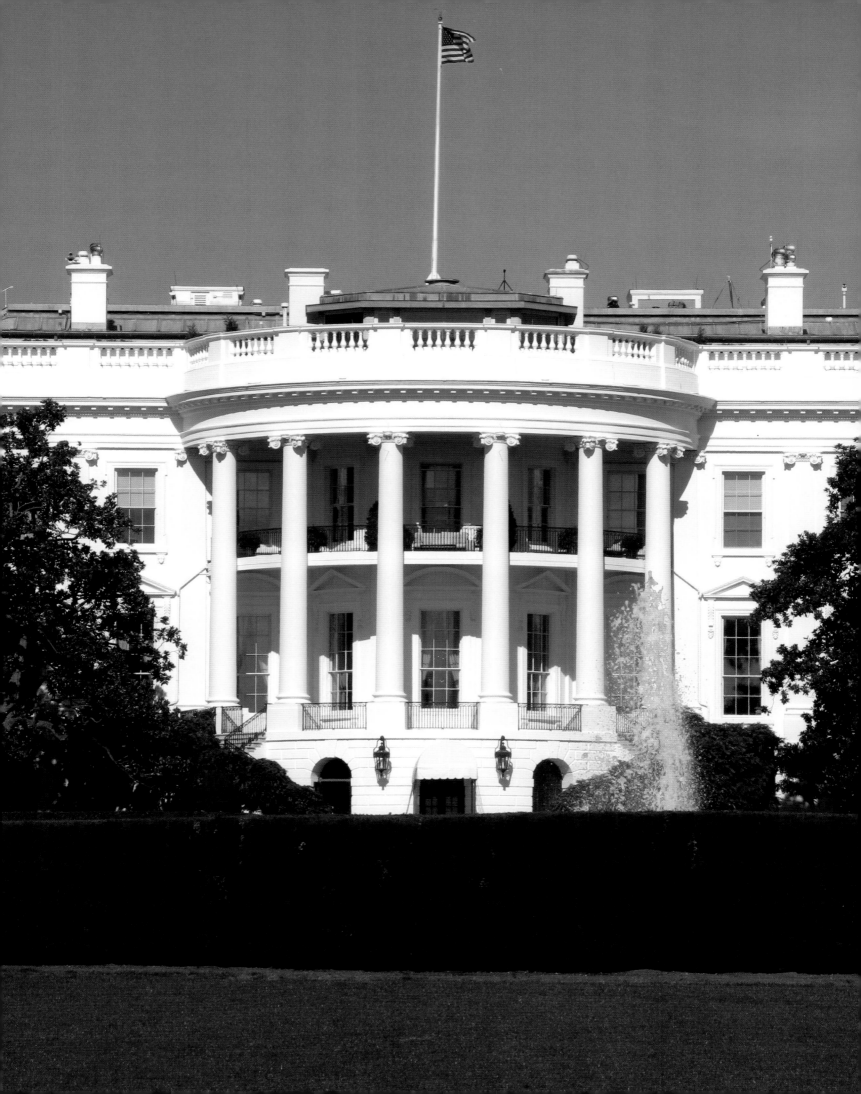

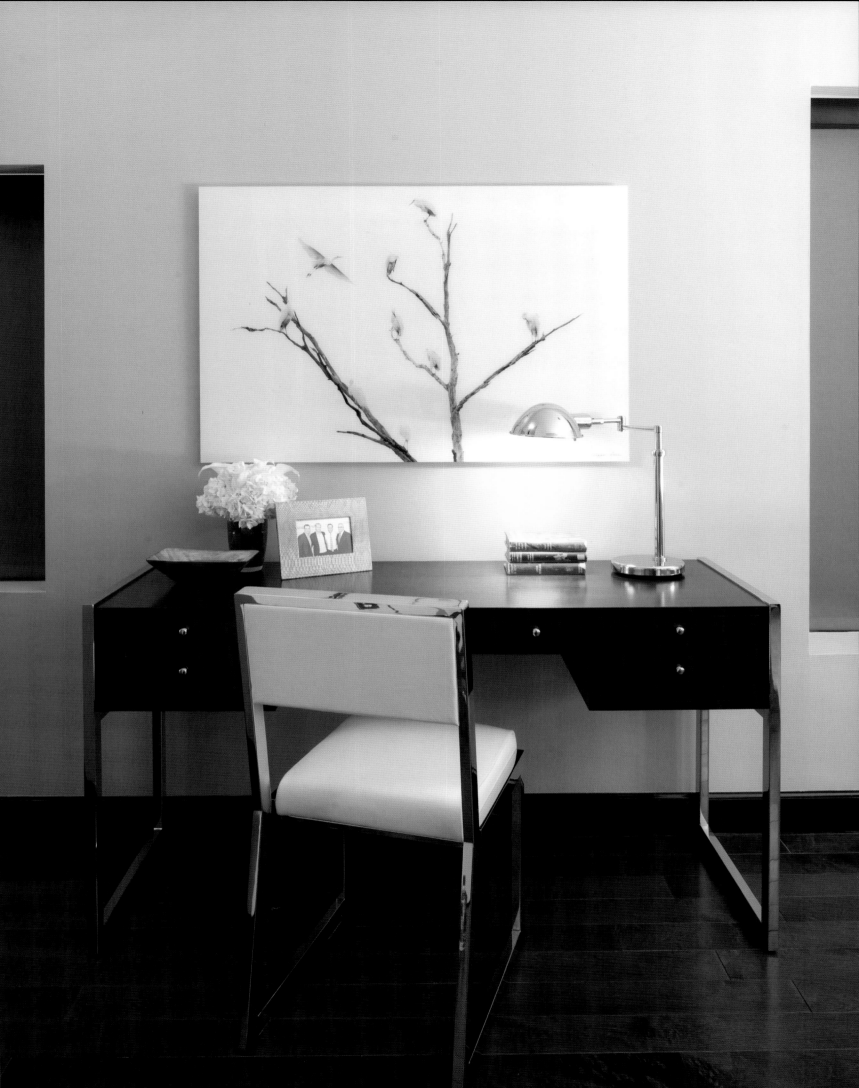

"The expression of our style can also be found in our own homes. They are our havens— and also our design labs. Rather than use focus groups, we pursue comfort on the most personal level. "

Opposite and following pages: From a *Traditional Home* article, Bob's North Carolina house, with the curved Finley dining bench, and his living room. *Previous pages, from left:* Over the years we have been lucky enough to be featured in the most wonderful magazines; a peek from *The Washington Post* at Mitchell and husband Tim's D.C. pied-à-terre. Above the desk is a Tipper Gore photograph from a collection we showcased in our stores.

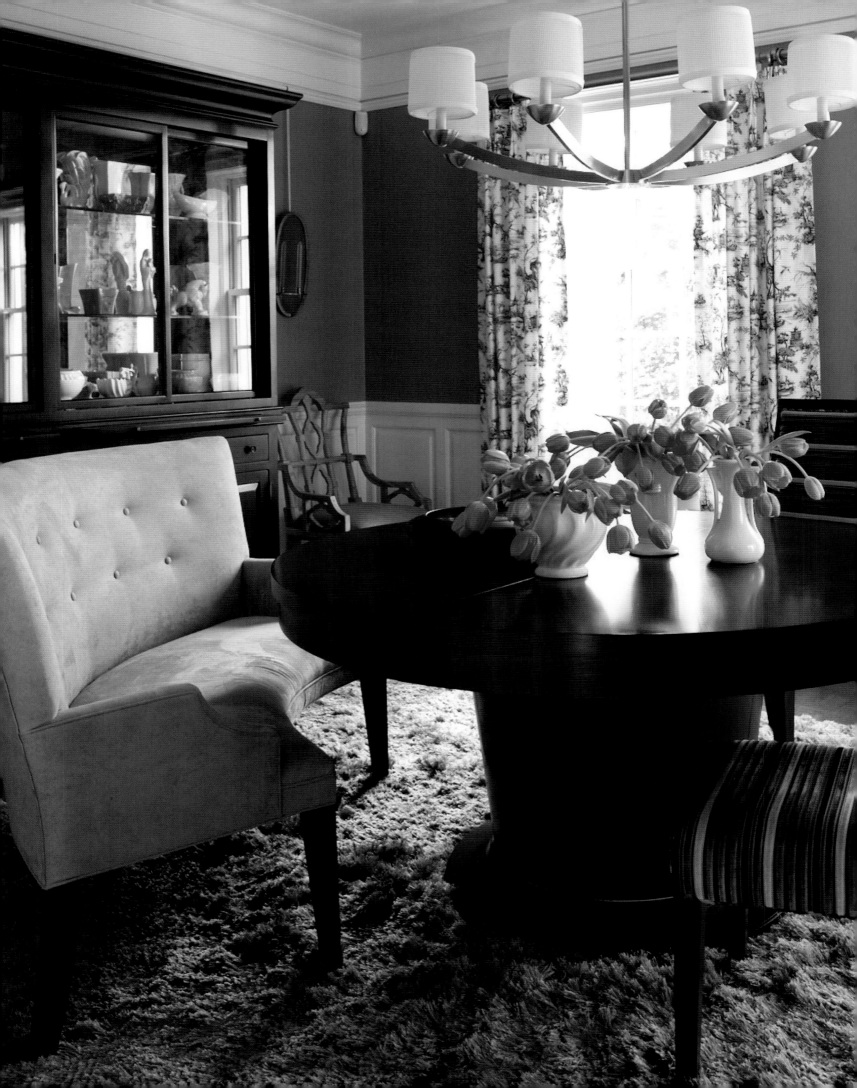

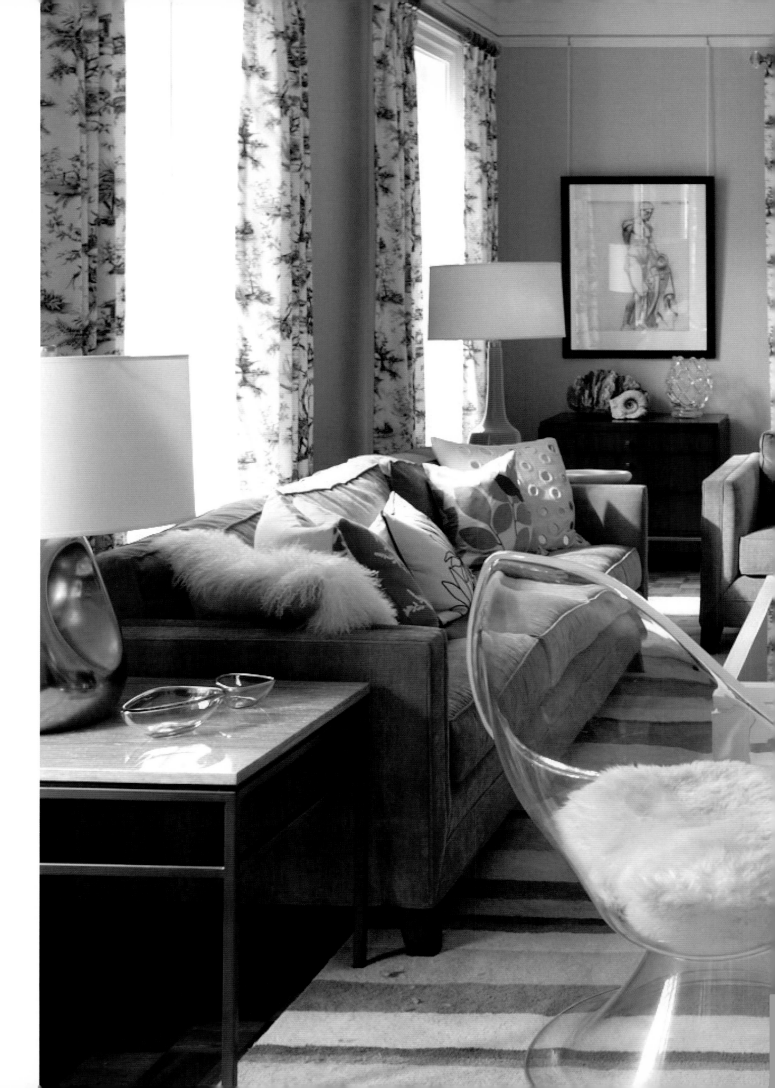

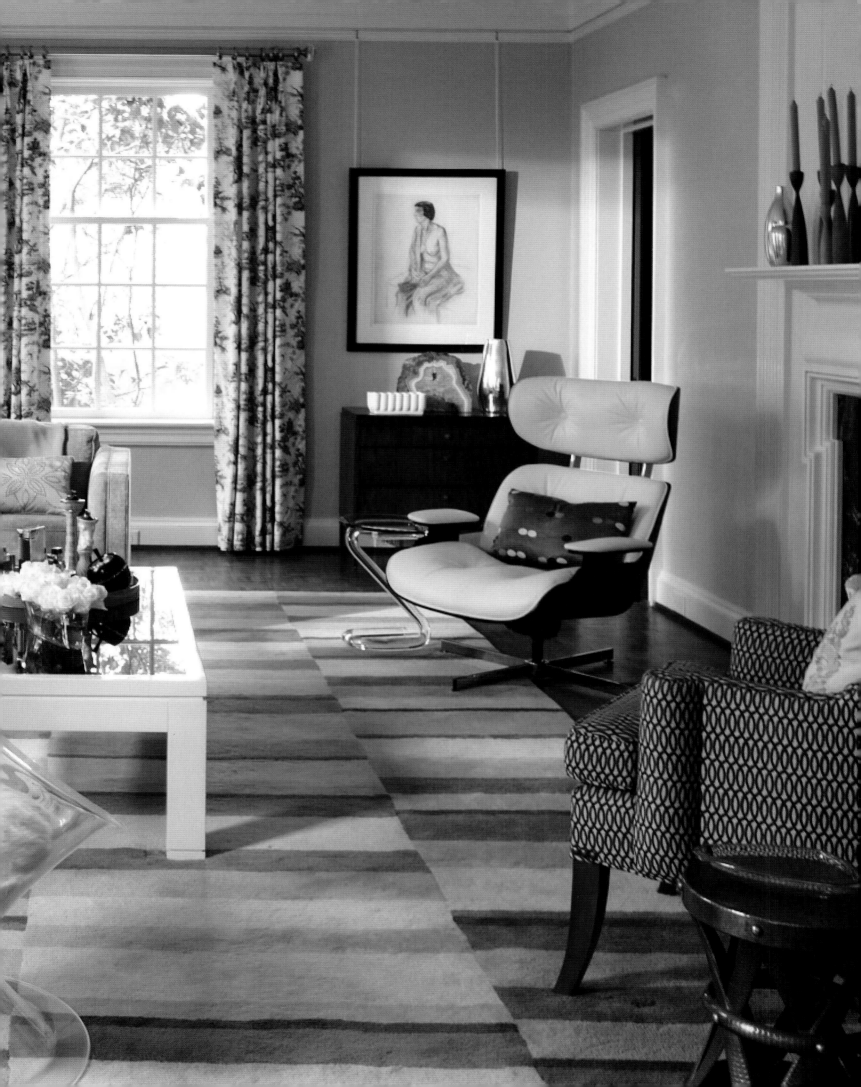

We believe in

Not I.

"I love walking through the factory and hearing the sewing machines and upholstery staple guns. To my ear, that's the sound of a symphony. It's truly a team effort, and when it all comes together, the result is some really beautiful furniture." —Mitchell Gold

The creation of our products demands the talent of countless individuals, beginning with our product-development team. From the first seed of an idea to the careful selection of fabrics, they spend months experimenting with scale, form, and function before a product is given a name.

The collective talent and passion of our craftspeople are then poured into the product's construction. More than six hundred people cutting, sewing, stuffing, and assembling—all working together in harmony. It's a breathtaking sight that still gives us goose bumps.

Once a piece of furniture is constructed, our meticulous inspectors ensure that it meets all of our quality standards. Only then is it ready to be packed by hand and delivered to your door.

It is this incredible teamwork we had in mind when designing our headquarters in 1998. To reinforce our flat hierarchy, the factory floor and management office are housed in the same building. Our employee gym, day-care center, on-site nurse, and café are available to all. At lunchtime it's common to see our designers, upholsterers, janitors, and managers eating side by side.

At Mitchell Gold + Bob Williams, "we" really is everybody.

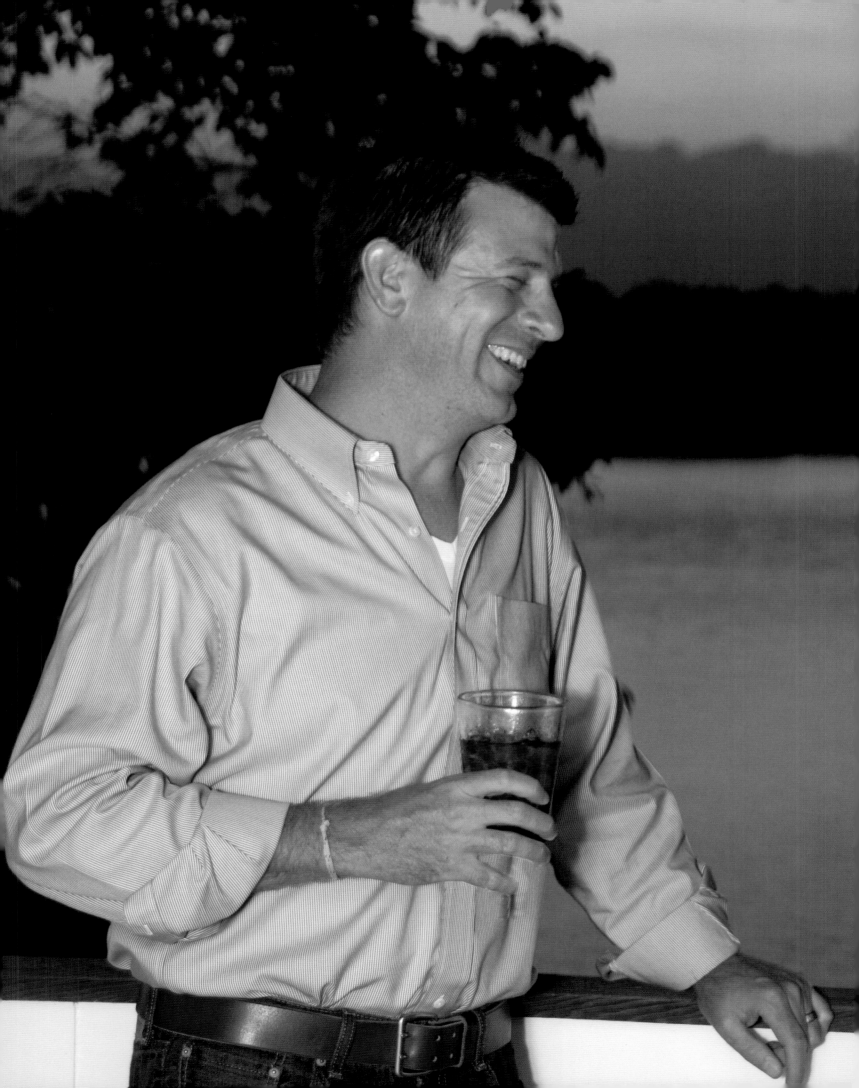

> "It's truly a team effort, and when it all comes together, the result is some really beautiful furniture."

“We said it in the headline of this ad that ran in 2000, and we stand by it: A Kid Deserves to Feel at Home.”

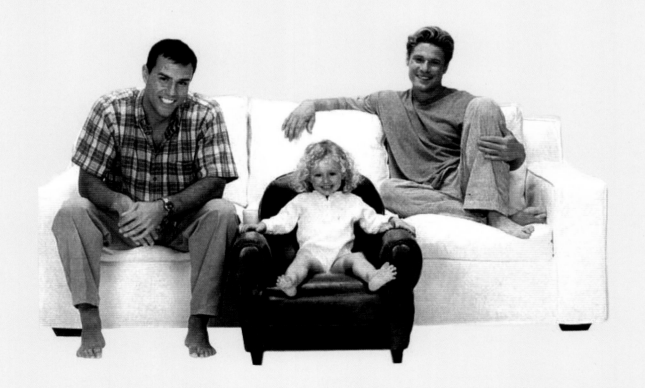

We believe children *enrich our lives*.
We believe in enriching the lives of our **children**.

One of our favorite times of day is around sunrise, when the first group of employees arrives at the factory to drop off their children at our day-care center. From the tiniest infant to rambunctious four-year-old triplets, each child is greeted by our day-care director, Kim Draughn, and her staff. We love to watch as toothy grins spread across sleepy faces. Their parents smile, too—knowing that, besides home, there are few places where their children feel so comfortable.

The creation of Lulu's Child Enrichment Center might just be our proudest accomplishment as a company. Named in honor of our beloved English bulldog, Lulu, it began with a simple idea that proved revolutionary.

We had noticed that one of our employees got a certain twitch around four o'clock in the afternoon. You know, that concoction of distraction and stress that arises when it's getting near time to pick up your kids. Then one day a lightbulb went off. We should have a day-care center right here, we thought, under the same roof. It should be open the same hours as our factory and offices, to put parents' minds at rest. It should be affordably priced. And it should be open to children from the surrounding community if space permits. For our employees, it would be more than a perk. If his child scratched her knee, Dad could simply walk down the hall and put the bandage on himself.

Our distressed leather kids' Parisian flea-market chair and easy-to-care-for washable white denim slipcover, featured in an early ad devoted to equality for all. *Following pages and page 82:* Our day-care center, then and now, including our first graduating class of 1999 and a more recent cap-and-gown ceremony.

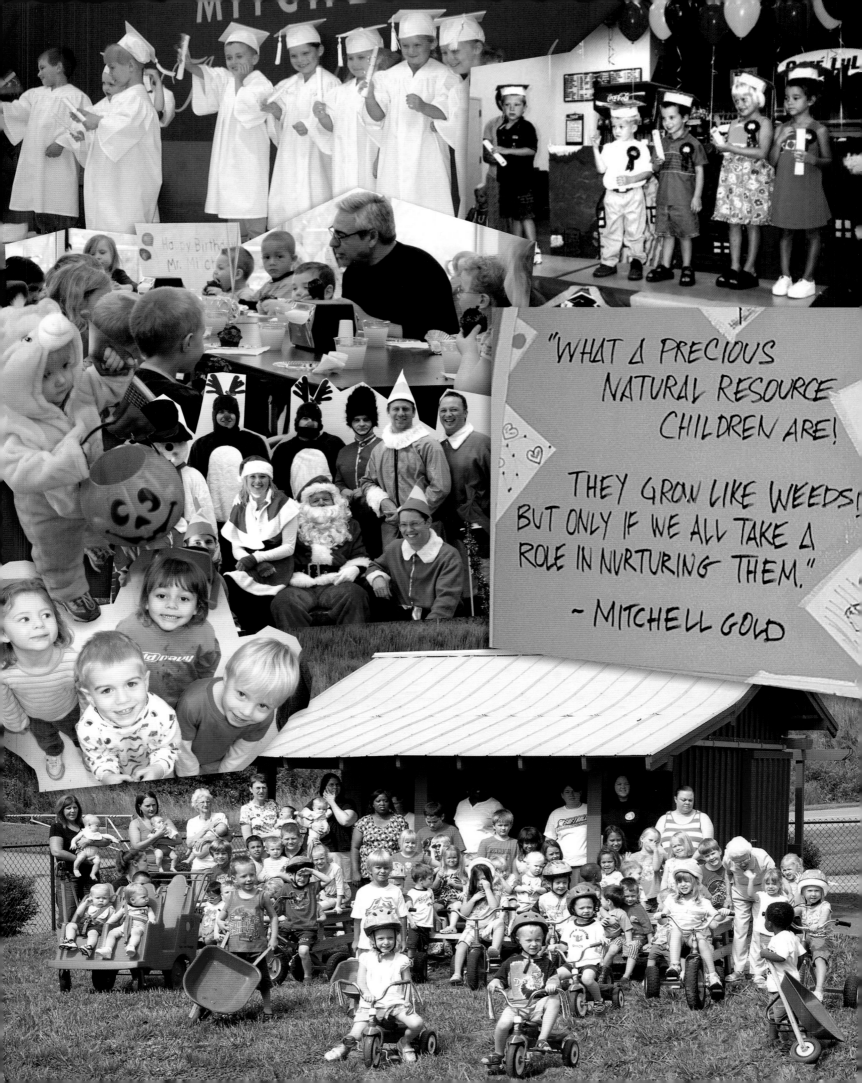

"WHAT A PRECIOUS NATURAL RESOURCE CHILDREN ARE!

THEY GROW LIKE WEEDS! BUT ONLY IF WE ALL TAKE A ROLE IN NURTURING THEM."

~ MITCHELL GOLD

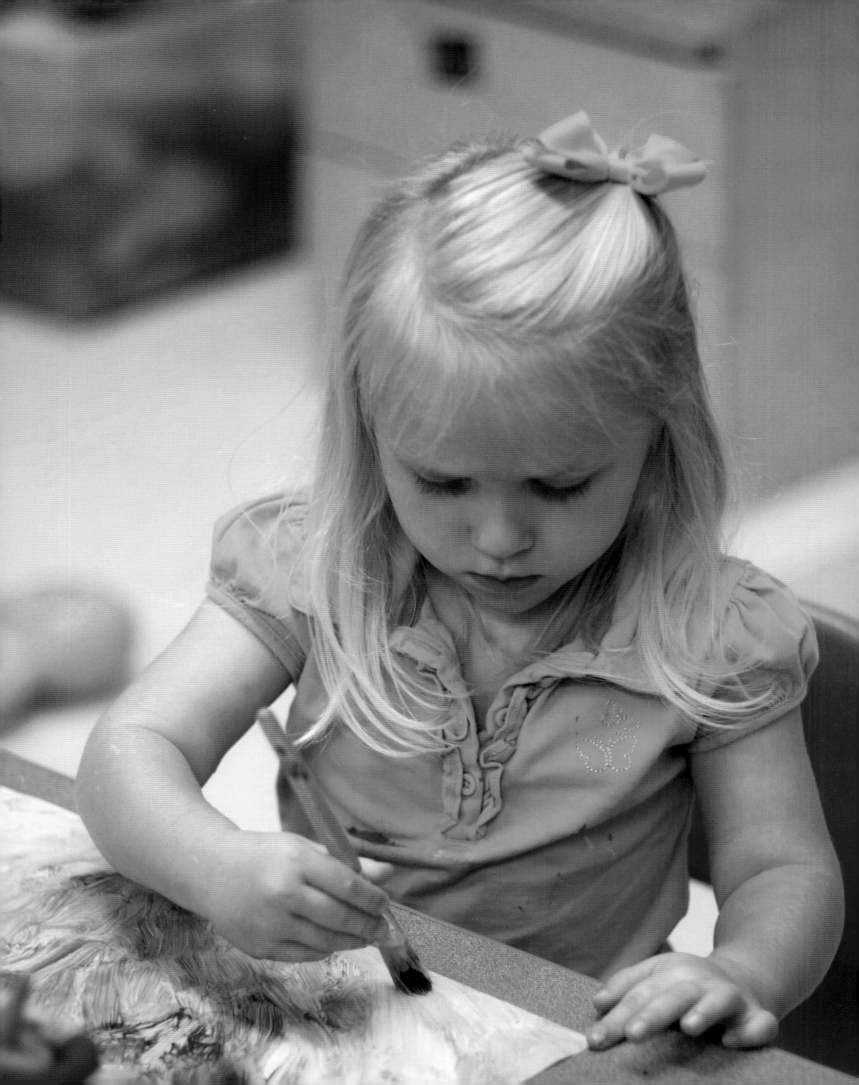

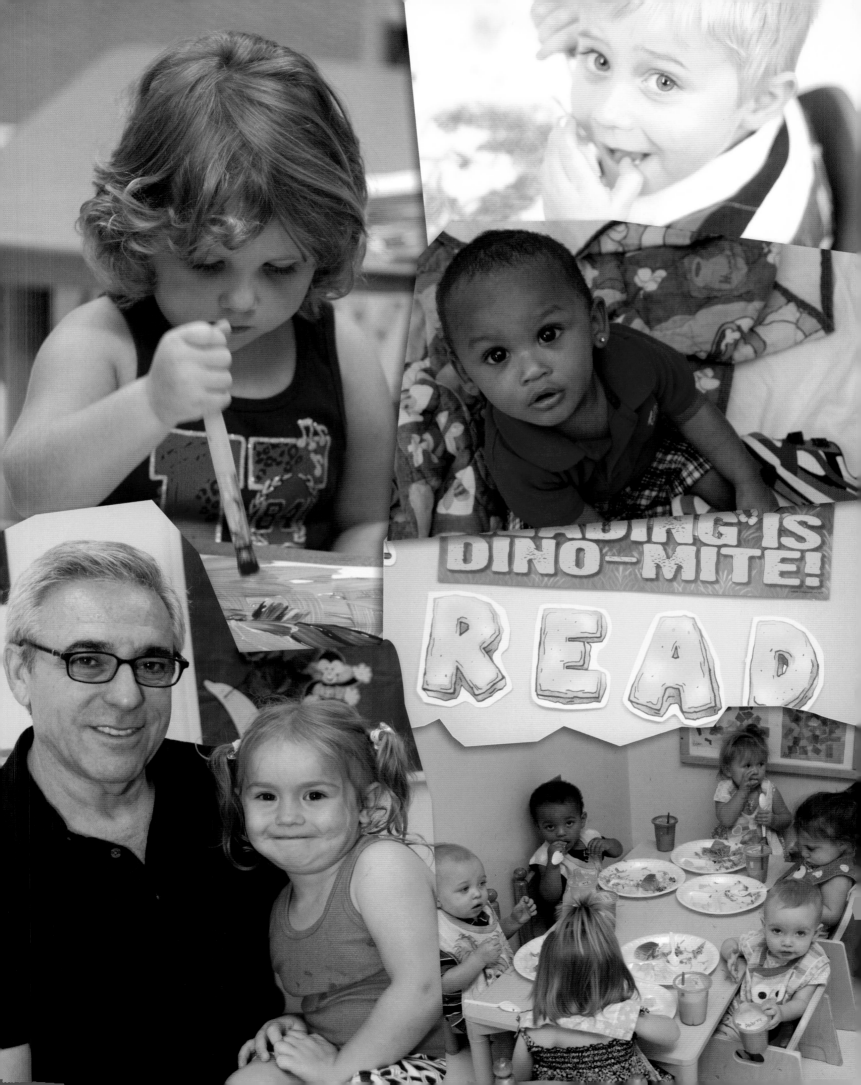

"The creation of Lulu's Child Enrichment Center might just be our proudest accomplishment as a company."

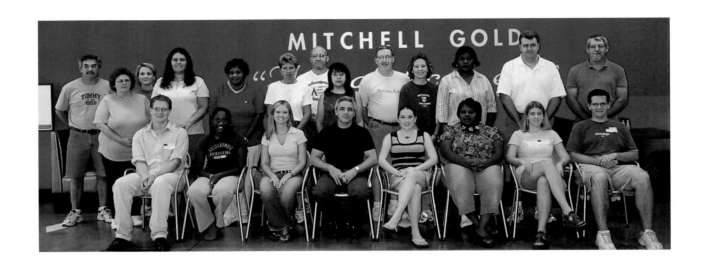

So in 1999 we broke ground on Lulu's Child Enrichment Center. It was the first on-site, education-based, nonprofit day-care center of its kind in our business. Our expert team developed a program to cultivate healthy eating and exercise habits. Children now harvest vegetables from the day-care garden and plums from the fruit trees that line our street, neatly named One Comfortable Place. Every activity—from the toys the children play with, to learning their ABCs, to social skills like waiting patiently while lunch is served—is individually tailored to each age group. By the time our kids leave for kindergarten, they are prepared and eager to learn.

More than 275 kids have graduated from our day-care program since it opened. (One even came back to work in the factory!) Graduation Day is undoubtedly the highlight of each year. We personally hand a diploma to each child, who joins us onstage clad in a miniature white cap and gown. And our commencement speakers have been special, too: One year, Bev Perdue, the first female governor of North Carolina, gave a speech. Another year, our U.S. senator, Kay Hagan, spoke. And last year, our Alexander County superintendent of schools, Dr. M. Brock Womble, joined us.

A group of scholarship winners at a recognition ceremony.

Lulu's Child Enrichment Center has received a prestigious five-star rating from the state and was named "Provider of the Year" in Alexander County. What makes us most proud, though, is that each child in our program has a head start on becoming a happy, healthy, and productive member of the community.

Within our community, we also sponsor many youth athletic teams. So many teams, in fact, that our factory's trophy case has run out of real estate. The only stipulation of our sponsorship is that each team name itself the Bulldogs, in some way—after Lulu, of course. Parents have reported scenes at the local soccer and baseball fields in which Bulldogs were playing almost every hour.

For kids who have set their sights on college, we offer another incentive: a college scholarship program. To receive a scholarship, children of employees need only write us a letter explaining why they want to go to school. The letter must be grammatically correct, and the scholarship must be for a school that prohibits all discrimination, including against sexual orientation. Each year, we hold a ceremony for the kids and their parents, and we give all students a dictionary and thesaurus to start them off well. Some of these kids are the first in their family to attend college. It is always a very moving day.

We genuinely believe that each of these programs is the right thing to do. For children, parents, the community, and the future. And as it turns out, doing the right thing has had broader implications for us—everywhere. It has been great for business. Our extensive benefits help attract an exceptional workforce. Many of our employees have been with us for years. Despite common wisdom, doing good does not necessarily conflict with a company's success. We know, because it's our secret to it.

We

don't

like

mean

people.

Being two gay men and, in Mitchell's case, Jewish, believe us when we say: We've met our fair share of bullies. And if those bullies taught us one thing, it's that we'd rather be nice guys.

We genuinely believe that being nice goes a long way. So from the moment we started our company, we made "nice" a top priority. We go out of our way to hire individuals who are patient, courteous, and kind. We will sometimes hire less-experienced people because they possess those characteristics, and then nurture their talents over time. It has worked out well for us.

It is important to us that all our employees feel comfortable—not just in the chair in which they sit while sewing, but also emotionally. We want to ensure their work environment is calm and nonthreatening. We want them to know that regardless of which job they do, they can count on always being treated fairly and equally.

Our philanthropic work with LGBT advocacy groups and women's shelters is an extension of this philosophy. Not only do we seek to help victims of harm, but we also strive to prevent it. We believe that deep down there are no truly mean people—so we continue to actively engage in efforts to educate about the damage done by abuse and bigotry—whether you're someone causing it or someone not standing up and speaking out against it. We have found that so many change their thinking and their ways simply by being made aware of the harm they may be doing.

Following pages: The exacting work of our upholsterers can be seen in the deeply tufted and nailhead-trimmed Claudette sofa, fabric-covered all the way to the floor, 1970s style. *Pages 90–91:* Our idea of modern sophistication includes extensive attention to detail, from the perfect taupe leather on the sofa to the right shade of emerald on the velvet chairs to the artwork that brings it all together.

We obsess

over

MINUTIAE.

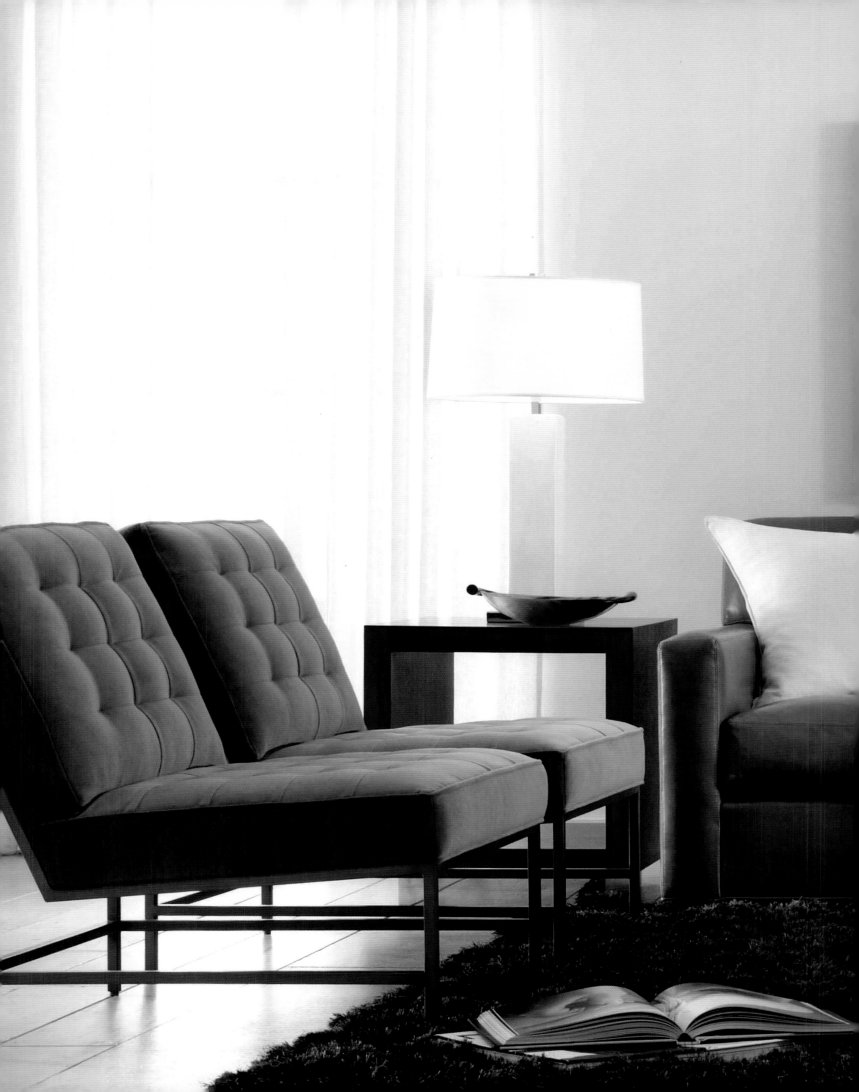

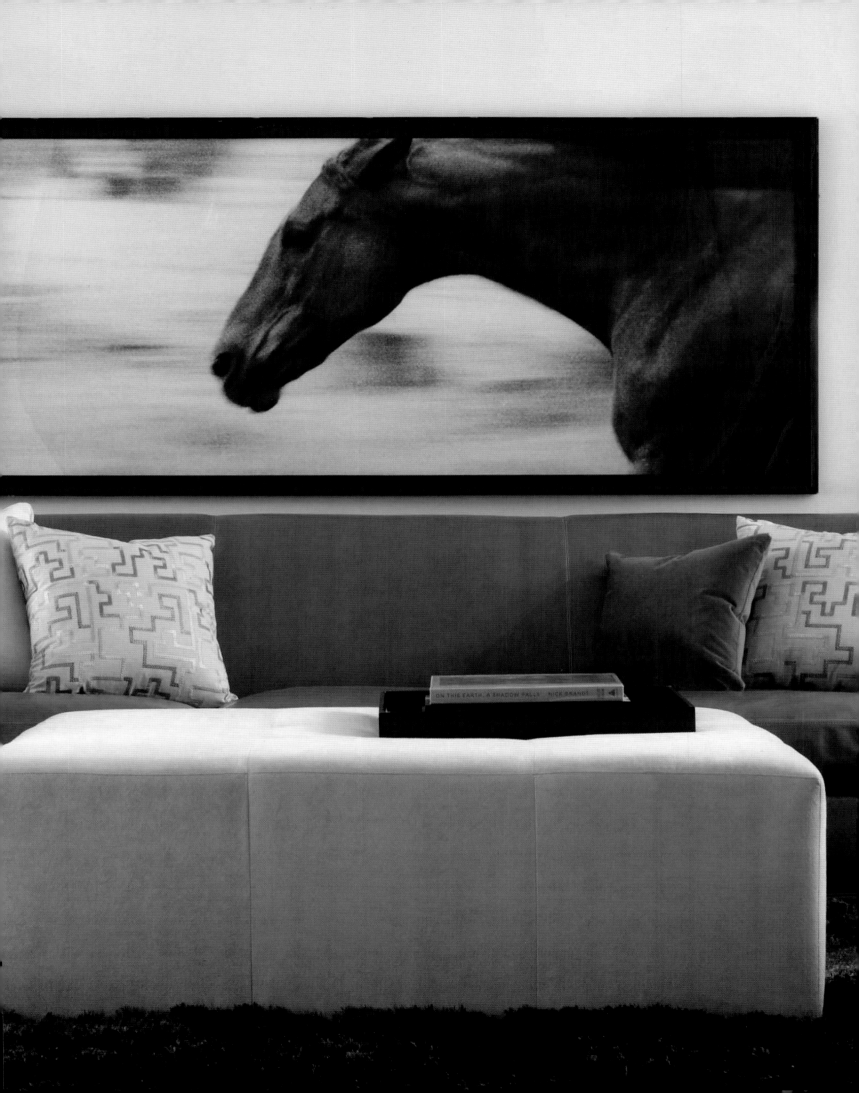

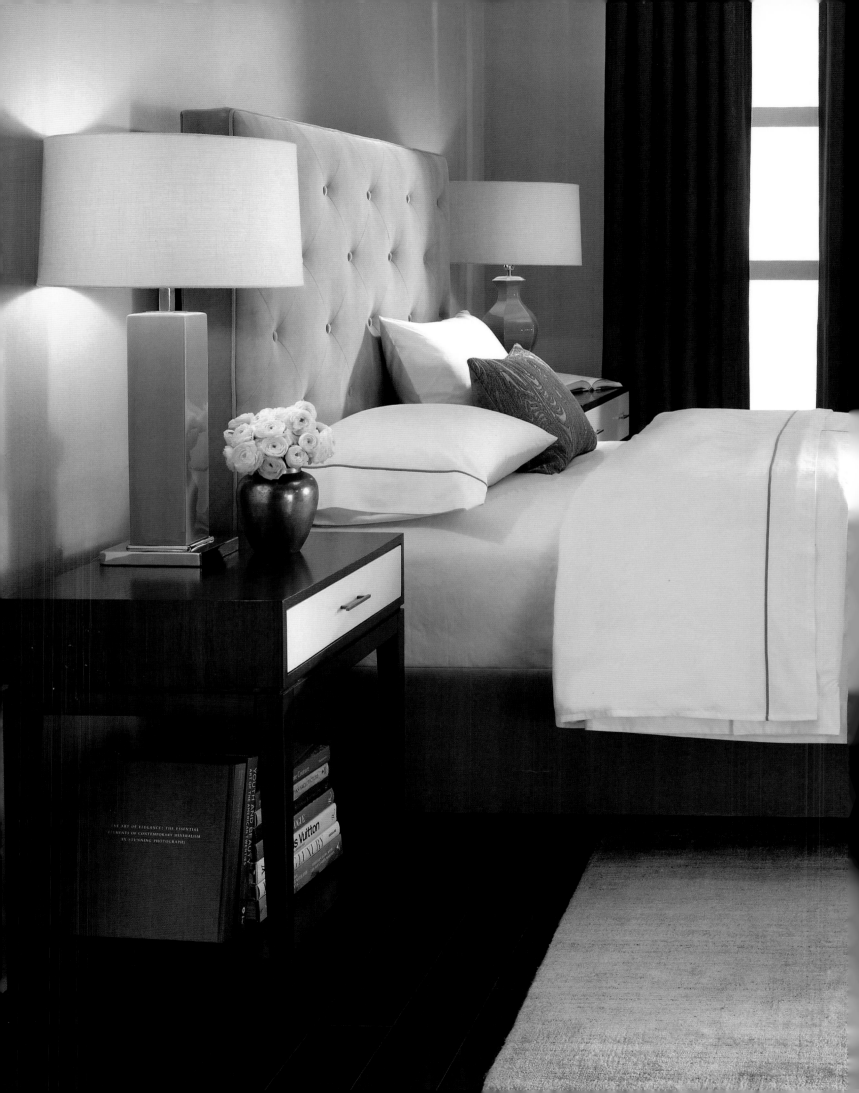

"We are not perfectionists, but we try to do things perfectly."

When we design a product, we always ask ourselves: What's going to be that extra little something? Will it be a button, nailhead trim, a caster? Or our red-lacquer drawer interiors that only a customer will see—and they will be their surprise and delight. Obviously we have different fabrics and materials to play with, but we also try to add that one detail that makes a piece sparkle and shine. It might not actually sparkle or shine, but the detail makes the sofa or chair, chest or table, rug or bed linens really stand out. And that's our goal: to create products that are well made, a good value, and finished with luxurious touches you won't find anywhere else.

When our pieces go into production, the attention to detail is just as fierce. Each yard of fabric is examined carefully. The color consistency of every pattern and solid is appraised under several types of light. Cushion seams are carefully sewn. Each step of the way, our furniture goes through rigorous quality checks. Such standards may be unheard-of in our industry, but we think they're worth it. The consummation of all that effort is consistently good quality. These are products that our customers feel confident buying—and that we can honestly say are beautifully made, by hand.

We pay attention to detail in all rooms—for example, an upholstered headboard that makes it great to read in bed. *Following pages, from left:* The carefully curated trim colors of our Luxe bedding collection coordinate with fabrics in our line; a 2000 ad: Treat Your Overnight Guests to Mitchell Gold.

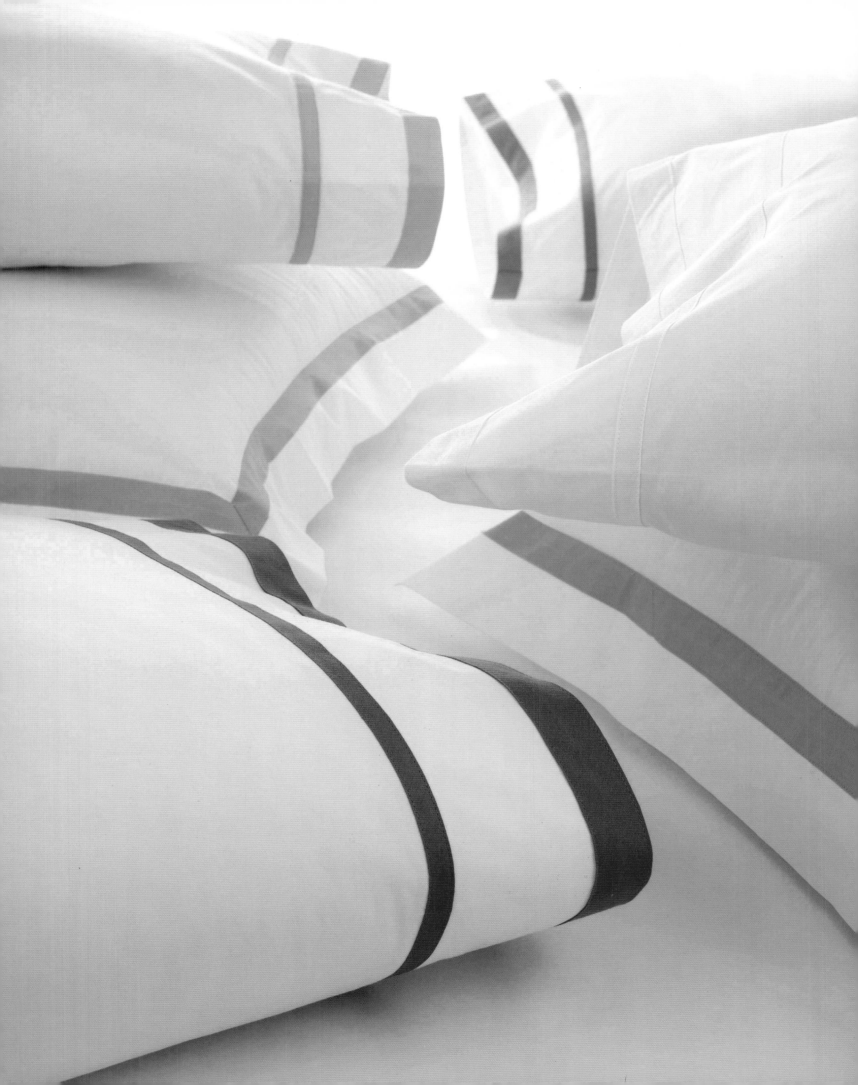

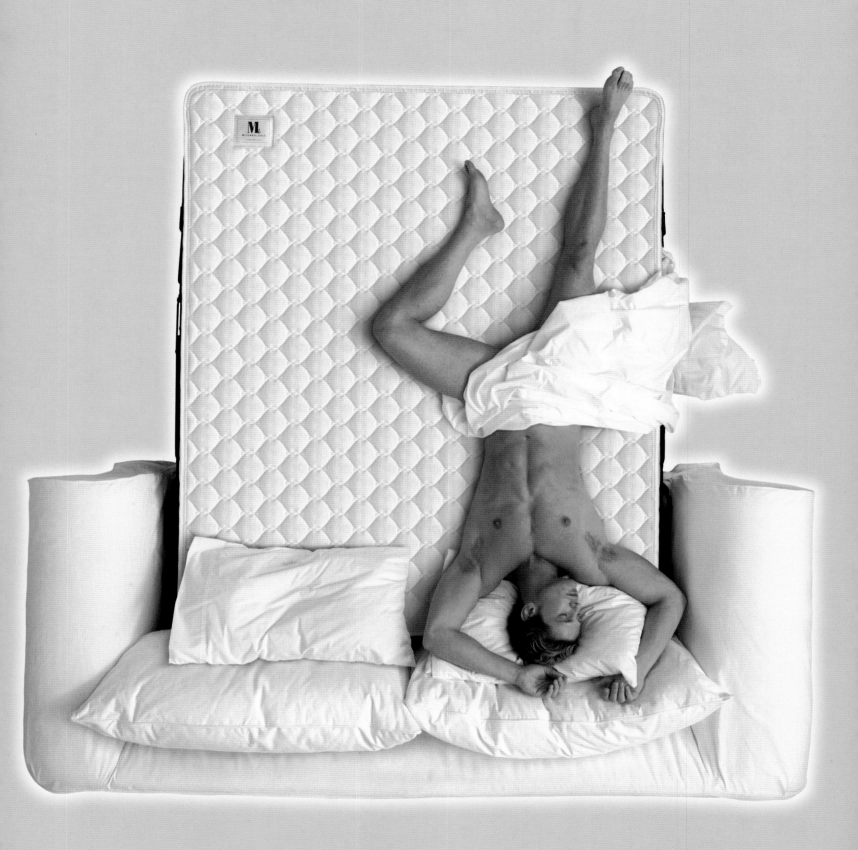

We are *timeless.*

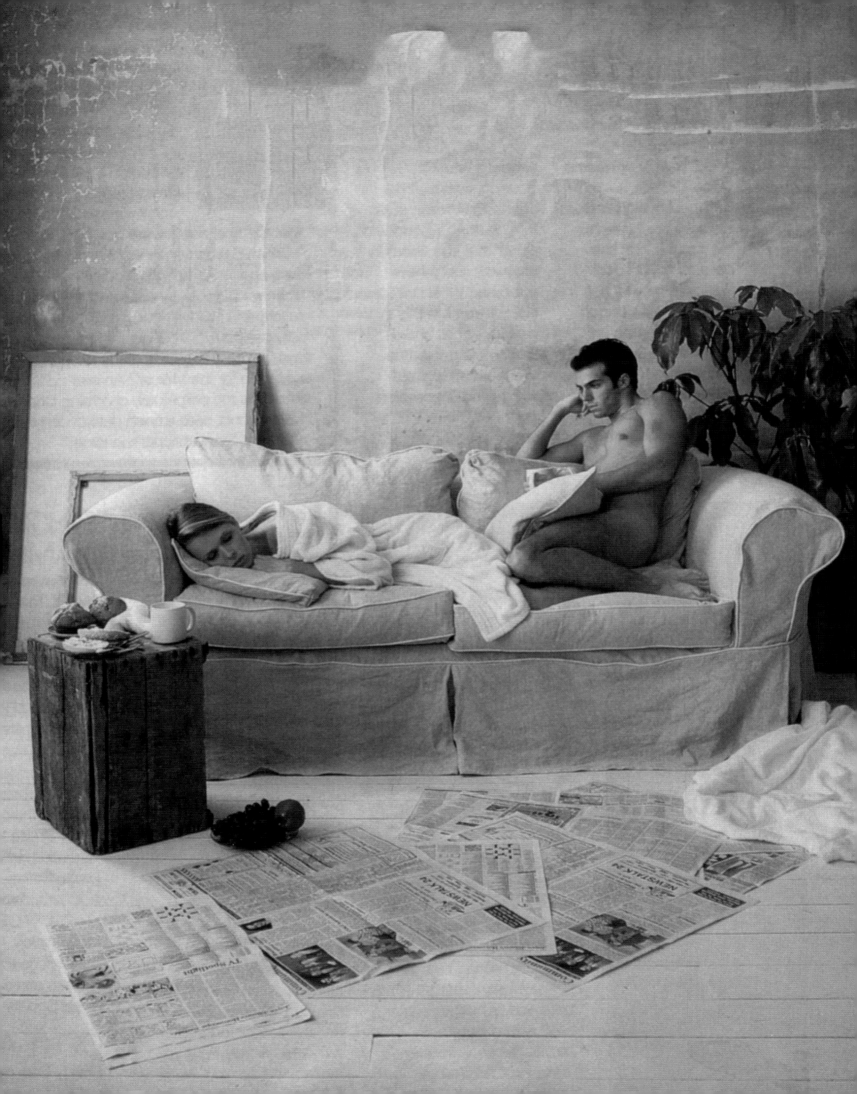

Furniture isn't fashion (although ours has often been fashion-inspired). It needs staying power because it's something that lives with you for years. So you should love it—really love it. Not just today or six months from now, but for a long time.

Everything we design reflects that simple philosophy. We are constantly focused on those timeless qualities that make a piece of furniture as alluring a decade later as the day you bought it. We distill those characteristics down to the bare essentials; perhaps it's the richness of a wood finish on a cocktail table or the curving side profile of a club chair. Once those classic elements are in place, we are free to interpret designs with a modern or traditional bent. Divergent styles can influence one another or masterfully mix without compromising the aesthetic integrity of each.

When it comes to decorating a home, the secret to achieving a timeless look is simplicity. We start with a soft, neutral palette and let accessories such as lamps, artwork, and collectibles—and sometimes a special accent chair—provide the oomph. Patterns and florals can easily overwhelm a room, so we use them to highlight it rather than anchor it. A unified color scheme of no more than four hues strikes the perfect balance of serenity and style.

A well-designed chair is like a truly comfortable home, You don't really have to think about it. It just *feels* right. Personally, we like to have that feeling all the time.

Our classic Parisian leather club chairs earned prominent spots on the floors of many of the top retail chains in the country. *Previous page:* From one of our earliest and most popular ad campaigns: Some People Just Know How to Live. This particular image is infamous, as *The New York Times* refused to run it due to male "side" nudity.

" A well-designed chair is like a truly comfortable home. You don't have to think about it. It just *feels* right. "

We're not trendy. Our goal is to fill a room with classic
yet modern-feeling pieces that you'll love for a long time,
like this setting—with our London leather sofa and Zondra
velvet chairs—which is as easy to envision in an English
library as in a modern American high-rise.

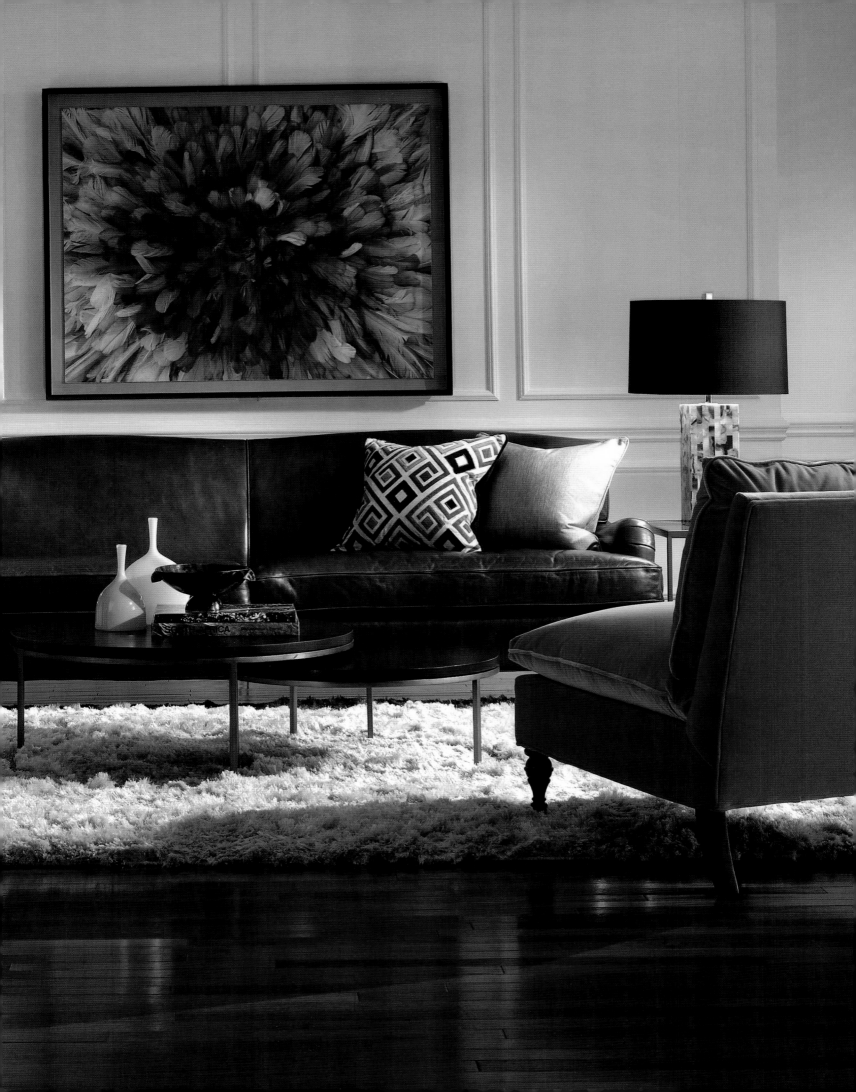

We LOVE pets.

Pets make a house a home. They provide us with comfort, they make us laugh, and they've never heard of Emily Post. When we design our products, we keep pets and the people who have them in mind. From washable slipcovers for our sofas to drool-forgiving fabrics, we make sure to always have easy-care decorating options for all the four-legged friends in our lives.

For many years, our English bulldog, Lulu, served as our muse. Her adorable, smushed-in face graced many of our ad campaigns and lit up the faces of our employees, customers, and the children in our day-care center. She faithfully went to the factory each day to fulfill her role as company mascot. Pattering from one desk or chair to another, she was always searching for a cozy place to sit. When it came to comfort, Lulu was our in-house expert.

Today we honor Lulu's spirit in myriad ways. When we eat a healthy lunch at Café Lulu, our company's affordably priced,

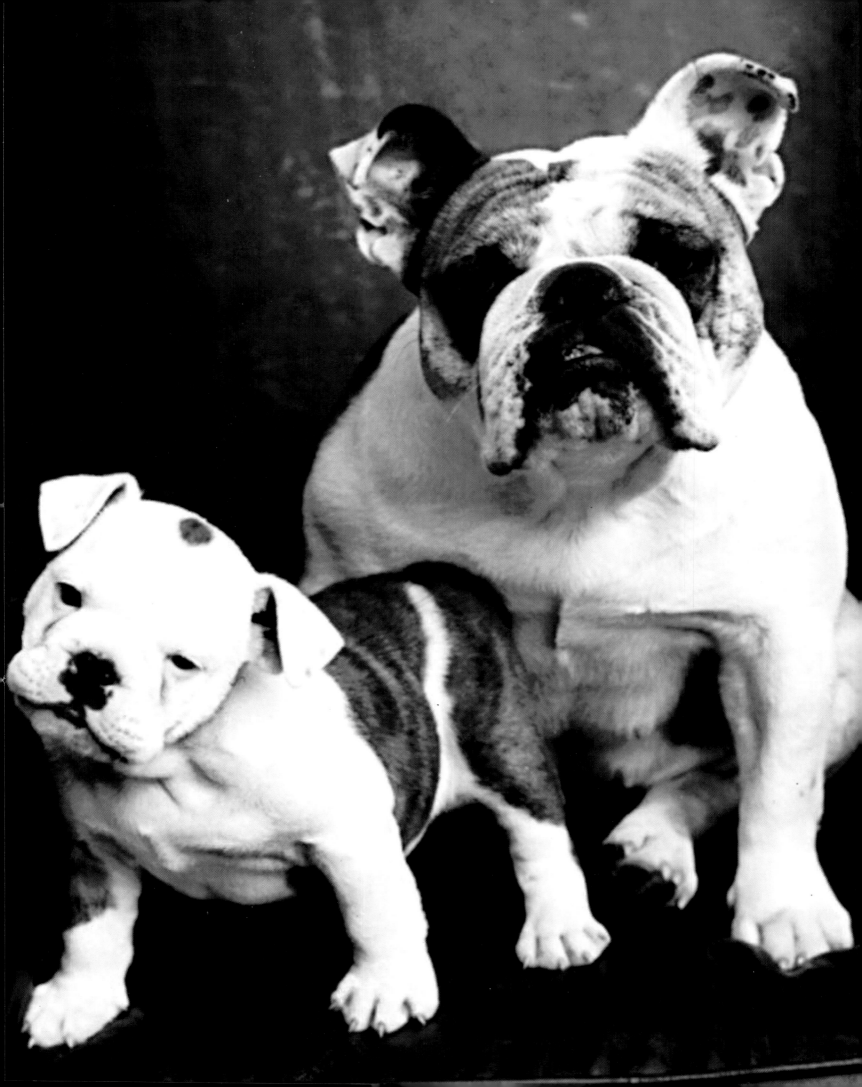

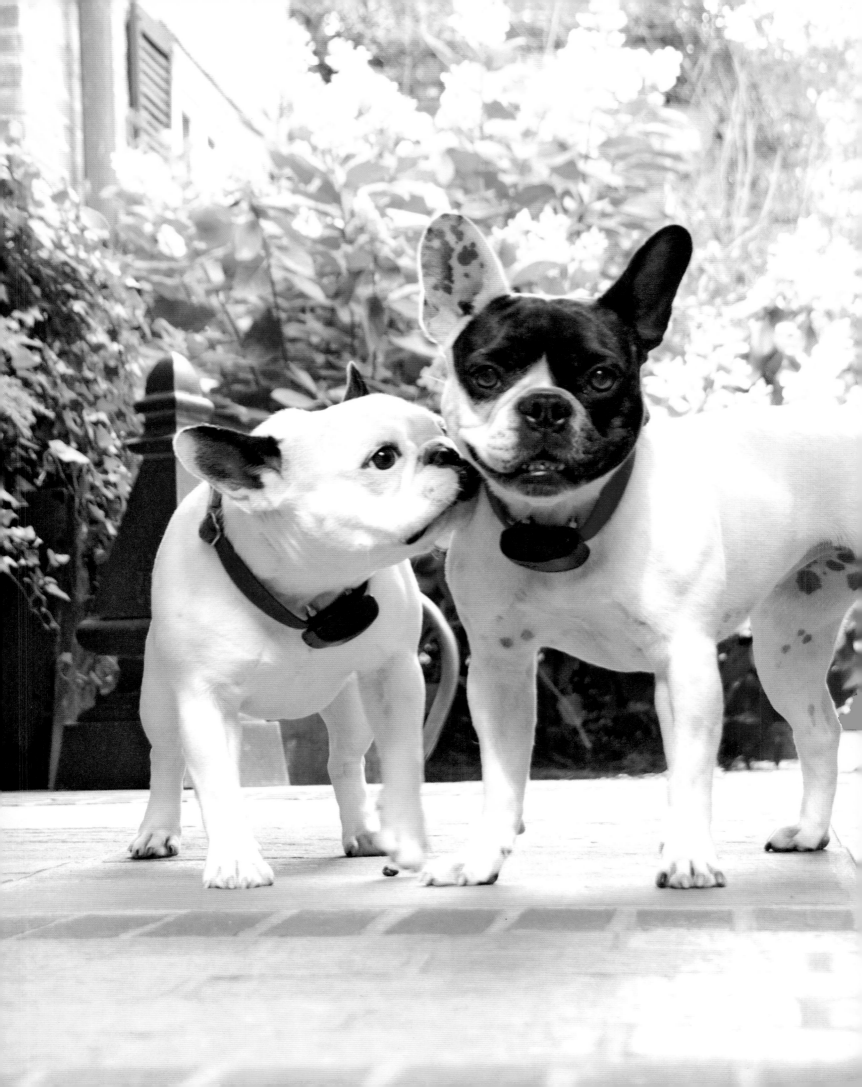

health-conscious, and chef-run cafeteria. When our employees' children arrive each morning at Lulu's Child Enrichment Center. When a customer shares a photo of his beloved pet on our Web site in the section called Lulu's Friends.

We really do love pets. (And especially dogs with smushed-in faces.) They are a great source of inspiration that should not be overlooked when furnishing a home. They remind us, multiple times a day, how nice it is to find a comfy chair, sit back, and relax.

The newest members of our family—from left, Lily and Violet, Bob's French bulldogs. *Previous pages, from left:* Us with Lulu and spaniel Sheeba when we were first starting out; one of Lulu's many birthday parties; Lulu's baby picture, 1995; Lulu in an ad; portrait of Lulu with baby brother English bulldog Spot. *Following page:* Lulu in costume.

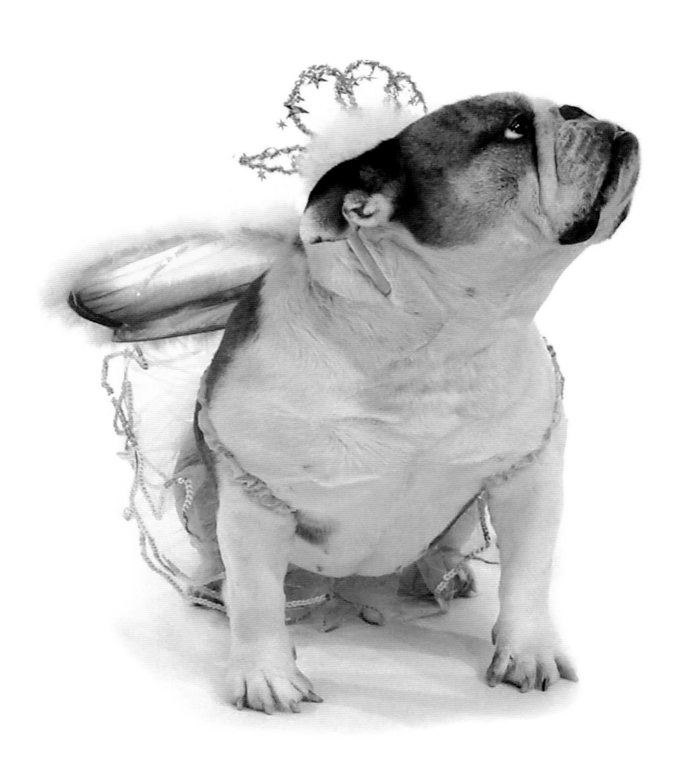

"For many years, our English bulldog, Lulu, served as our muse. When it came to comfort, she was our in-house expert."

We give to our

com-
muni-
ties.

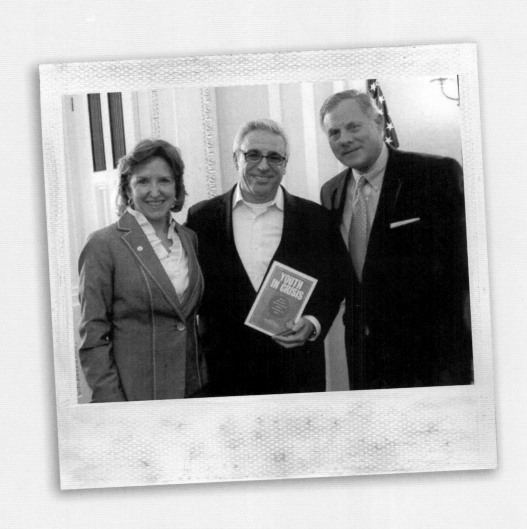

When our business started to grow and become successful, we immediately wanted to give something back. We saw it as an opportunity to help those less fortunate and to champion causes close to our heart. Today Mitchell Gold + Bob Williams is teamed up with nonprofit organizations across the country and in our local community working to end discrimination and violence on many fronts and aiding individuals with life-challenging illnesses.

We support several organizations dedicated to educating Americans about the harm caused to young people when they are not treated equally, both spiritually and politically. One of the most exciting new projects we are supporting is the creation of a National LGBT Museum of history and culture in Washington, D.C., being developed by Mitchell's husband, Tim Gold.

Our allies in the fight against HIV/AIDS include DIFFA (Design Industries Foundation Fighting AIDS), one of the largest care and outreach organizations in the country, and ALFA (AIDS Leadership Foothills-area Alliance), which provides local support and education to communities in North Carolina near our factory.

Another important local charity we support is Exodus Homes, which provides housing, training, jobs, and support to recovering addicts and ex-convicts returning to our community.

Women's health and safety are also important to us. Over the years, we have partnered with V-Day, a global organization devoted to ending violence against women and sexual slavery, as well as the Ovarian Cancer Research Fund, which strives to find a cure while providing support for patients and their families.

Mitchell in 2011 at a reception in the Capitol Building in Washington, D.C., where both U.S. senators from North Carolina, Kay Hagan (D) and Richard Burr (R), honored him for his work with LGBT youth. *Following pages:* One of the most wonderful organizations we work with is Exodus Homes. They are so important to our North Carolina community.

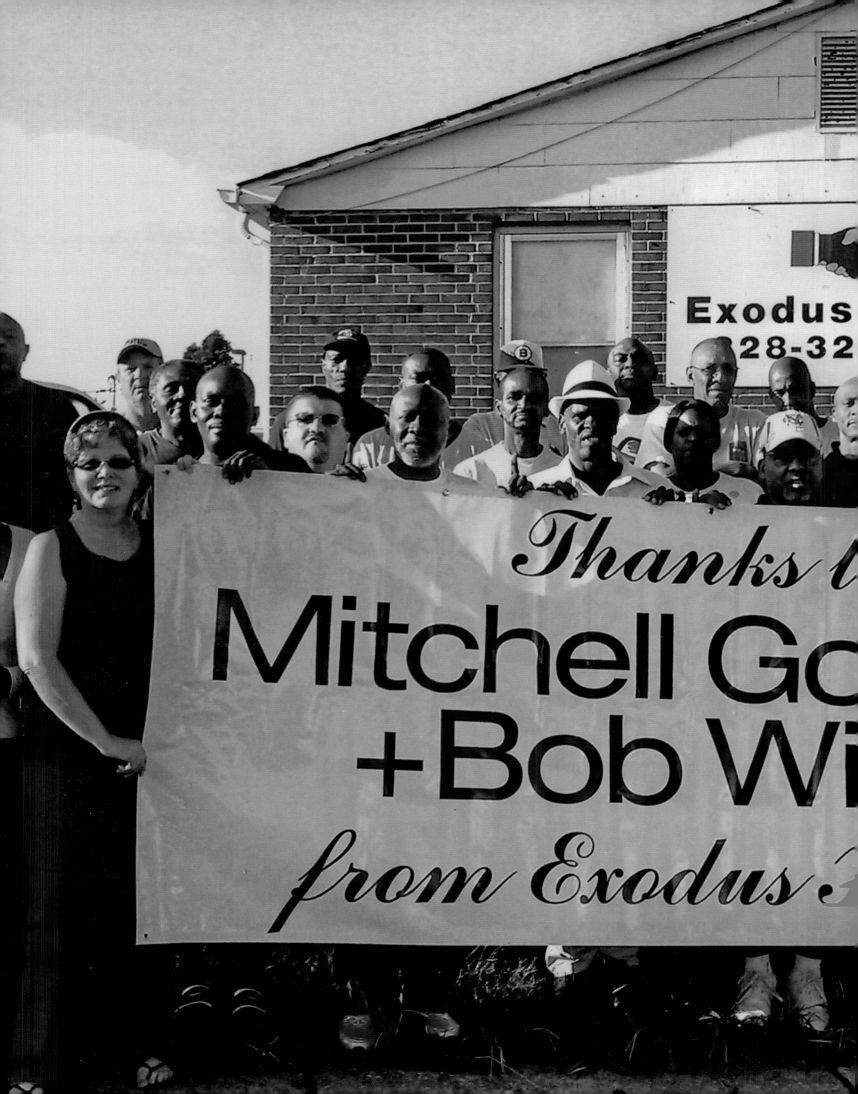

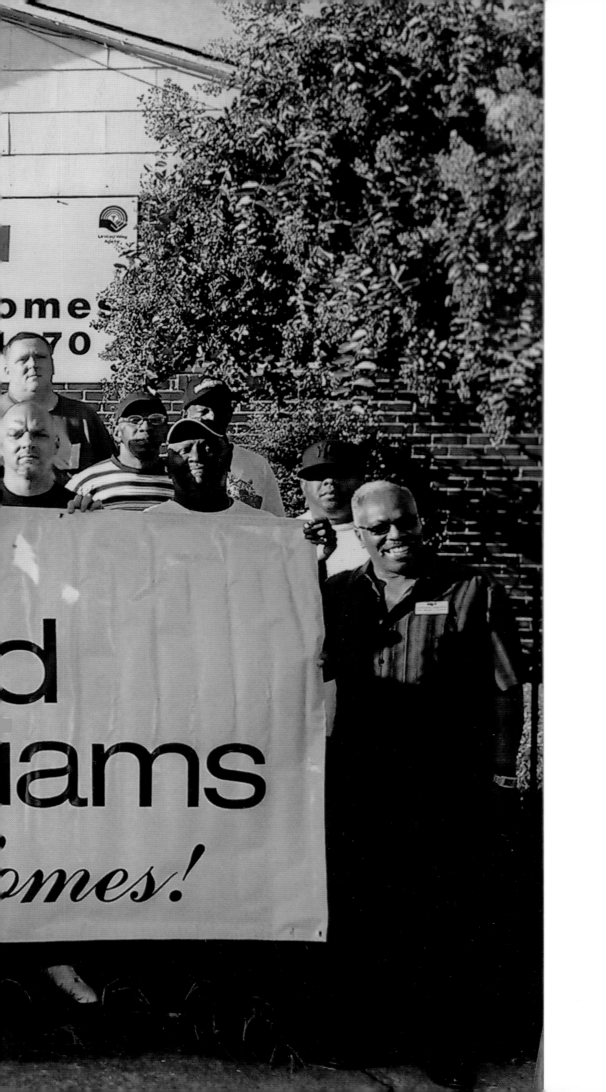

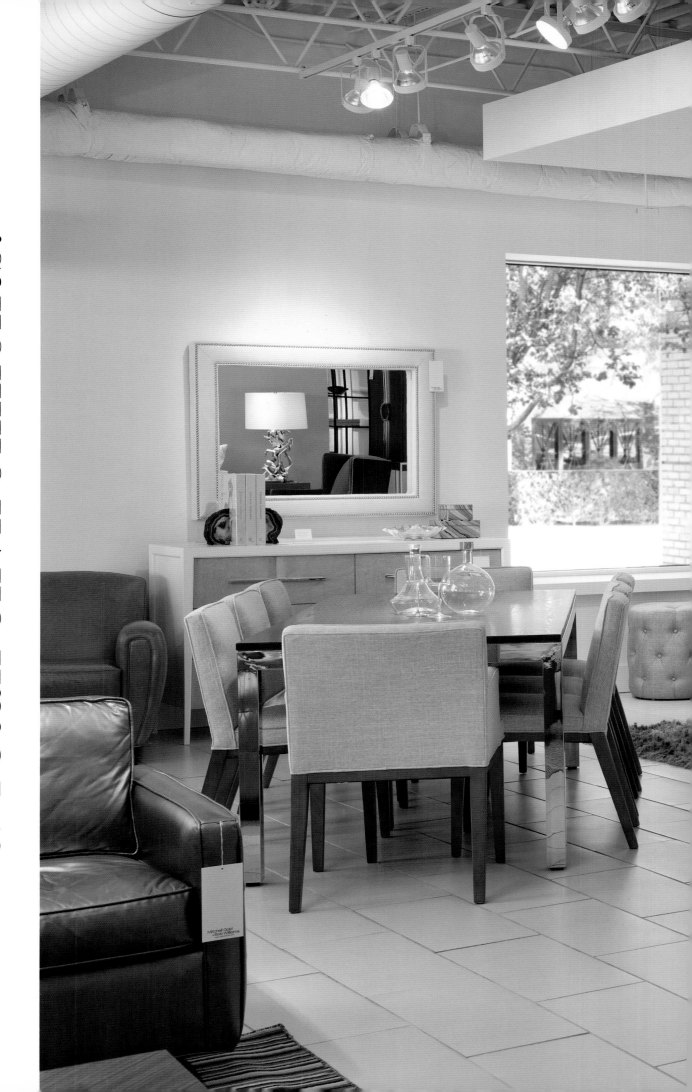

We present our collection in the most spectacular of **retail environments.**

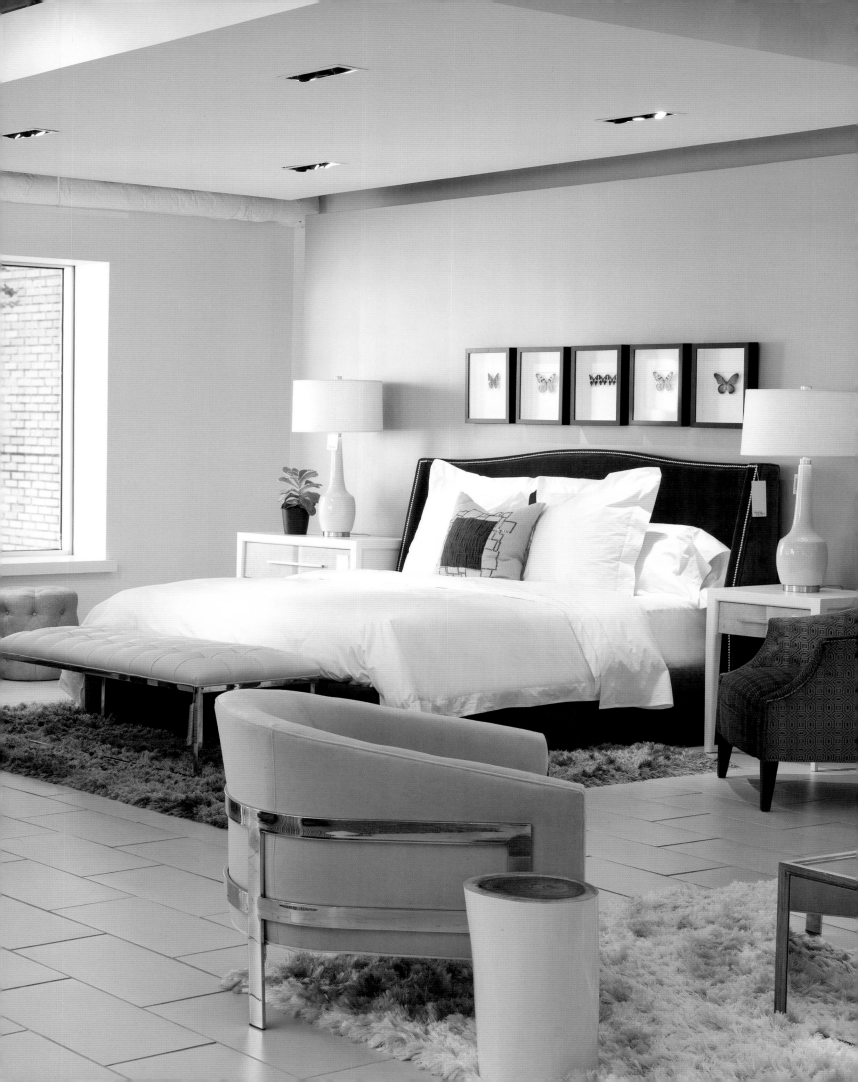

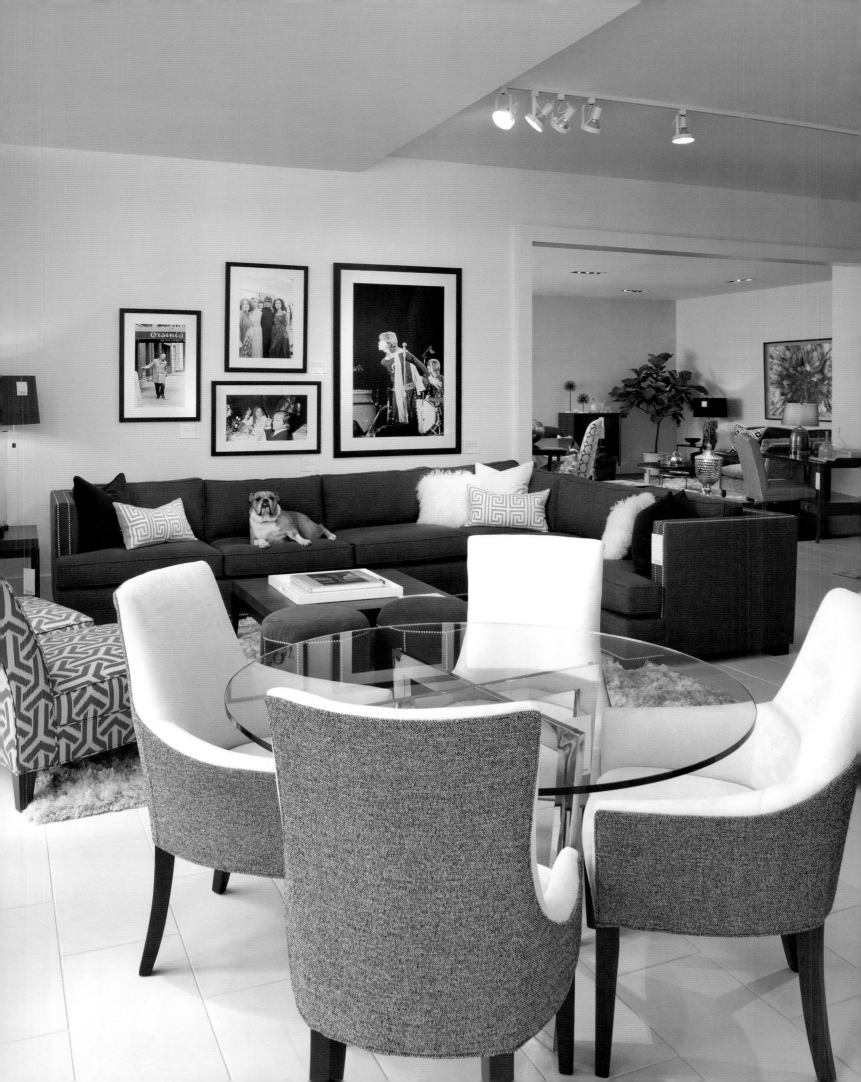

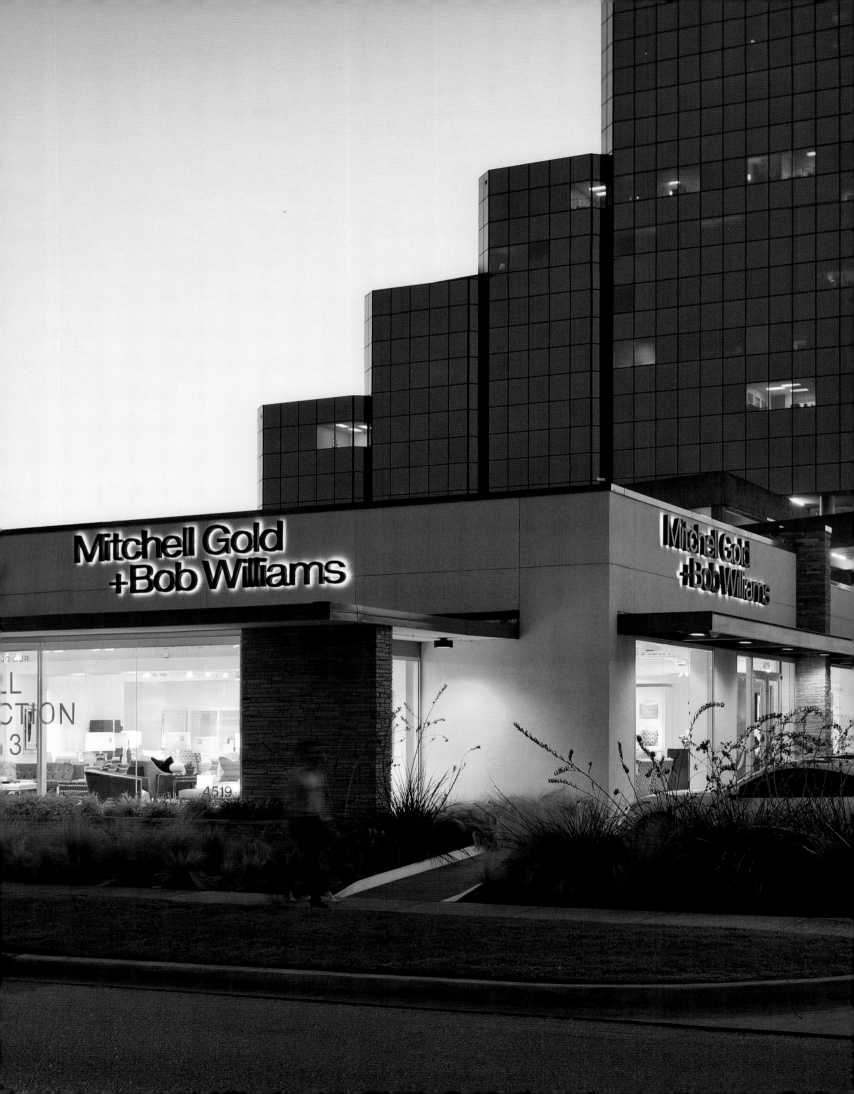

"We want to be the absolute best retailer. To provide the most exceptional experience from the moment you first experience our brand in an ad—when you pick up, say, an issue of *Elle Décor*—to when you go to our Web site to see who we are, to when you walk in the door of one of our stores and someone greets you with a warm, friendly smile and a nice hello. We are not high-pressure salespeople. We don't sell you anything you don't need. We just want to help you be comfortable in your home. Our job is simply to make people comfortable." —Ken Hipp, senior vice president of retail stores

Decorating a home can be a stressful experience, so we designed our stores to make the process as relaxing as possible. The idea was to create an environment as serene and inviting as the home you're looking to furnish. When you step inside, it feels like an oasis of quiet and calm.

We let you get at least sixteen feet inside before we even approach you so that you can take a breath, look around, and get your bearings. And there's never any pressure to buy. We ask simple questions like "Are you looking for anything in particular?" And then we answer your questions—clearly, directly, and accurately—instead of using some silly sales technique.

Each of our stores is a showcase of beautiful, well-designed products—but never too many. Wide, spacious aisles let you examine room setups from a distance or snap a photograph unobstructed. Every product's name, dimensions, materials, and in-stock status are listed on its price tag. Even the overhead lighting has been considered: low, intimate light in the bedrooms and crisp natural light in the dining rooms.

What was the inspiration for our commitment to making things calmer and easier for our customers? Years ago, when we were first starting out,

Pages 114–115: Interior of the Dallas store, showing the Fall 2013 collection.
Previous pages, from left: The Mitchell Gold + Bob Williams Signature Store in Plano, Texas, showing the Fall 2013 collection; exterior of the Mitchell Gold + Bob Williams Signature Store in Dallas, Texas.

we happened to watch an Oprah Winfrey show where she went out on the streets of Chicago and asked people how they felt about decorating and buying furniture for their homes. To our surprise, most of them responded that it was one of their most stressful experiences. We decided then and there to change that—and have made many decisions on how we do business based on it ever since. One way our design associates do this today is by helping customers who want to create a comfortable room first answer a few key questions: How will the room be used? What activities will go on there? Who will use the room? Knowing their responses makes it easier to choose everything from furniture to fabrics to accessories. It answers questions from which pieces to place in the room to whether the sofa should be geared toward lying down and watching TV, sitting up and conversing with company, or both.

What you see in our stores mirrors what's in our current catalog. If you are looking for immediate gratification, you can buy anything on the spot and have it delivered in a week or two. Or you can choose from a tightly edited group of luxurious leathers and fabrics. We will send you home with a swatch—or two or three or four.

Our phenomenal design teams can assist you in the store or visit the place you are furnishing for a small, refundable fee. They will answer any questions you have by phone, e-mail, or text—whichever you prefer.

Since 2003, we have opened twenty-one Mitchell Gold + Bob Williams Signature Stores across the country and abroad. Five to six more stores a year are planned for the foreseeable future, all in beautiful, convenient locations with easily accessible parking.

Following pages: The Mitchell Gold + Bob Williams Signature Store in SoHo, New York City.

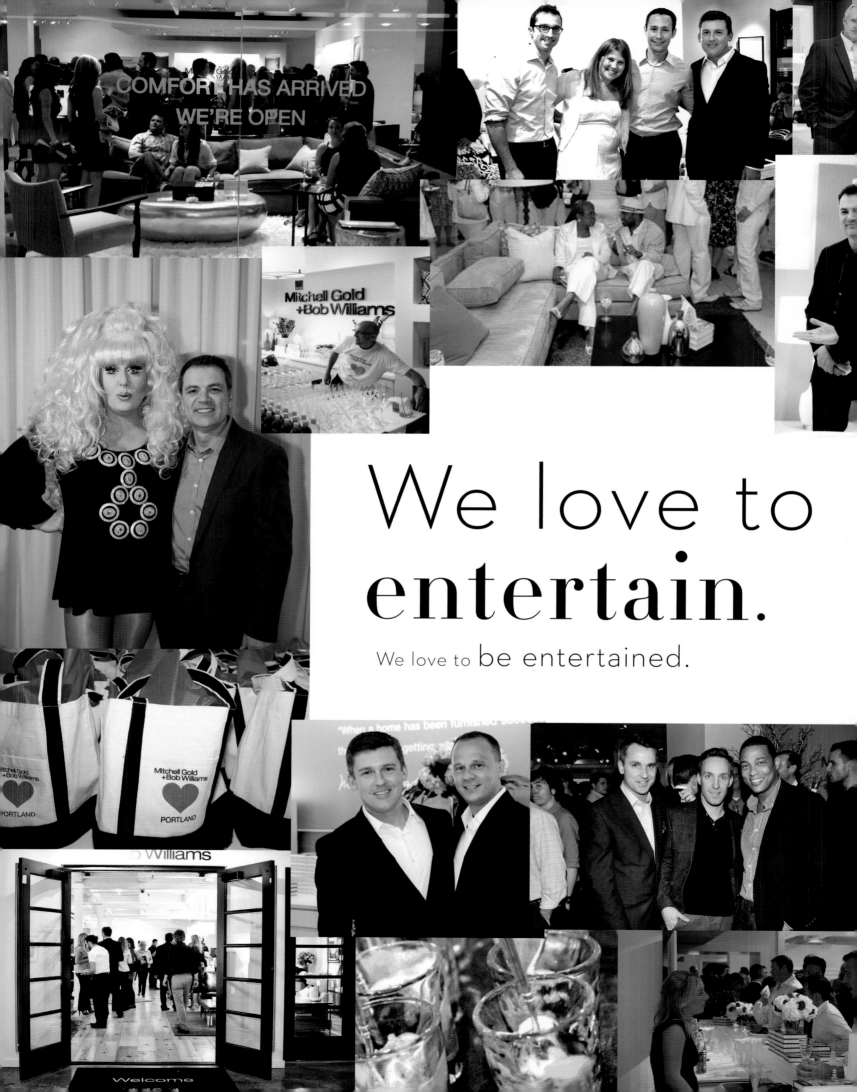

We love to
entertain.
We love to be entertained.

It's hardly a surprise that our first products were designed with entertaining in mind. Comfortable upholstered dining chairs that let you linger over the dinner table for hours. Washable slipcovers that soften up a room while making the inevitable spill a breeze to clean. We still make those products—and we have them in our homes. As people who frequently entertain, we know: The fewer things a host has to stress about, the more guests will feel at home.

That's the "art of entertaining," if you ask us. It's not about making things perfect. It's not about having the most extravagant place settings, floral arrangements, or spread. Simplifying your living space and considering how you actually use a room can go a long way. For example, letting people serve themselves from platters on a sideboard ensures that all your guests eat exactly what they want. Placing flowers in a short vase makes it easier to talk to guests—or pass a bottle of wine—across the table. Thinking ahead about where to stash those dirty dishes frees you to continue the good conversation, instead of hiding in the kitchen. These are just some of the tricks we've learned over the years. The secret to making guests feel at ease is being relaxed yourself.

For us, entertaining is a way of life. Whether hosting a cocktail party for five hundred at one of our stores or an intimate dinner with friends, we relish treating guests to a wonderful night out. The busiest times of year are the two High Point Market weeks, when the entire home-furnishings industry gathers in North Carolina for the biannual trade shows. Every night we host a different dinner for customers and the media, at the house we bought just for these markets. We realized that many of our guests are frequent travelers who, like us, crave nothing more than the comfort of a

home-cooked meal. With the help of our corporate chef, Sean Robinson, we offer them the next best thing: delicious food and the domestic bliss of our place.

Food is one of the most gracious ways to communicate to people that you're happy they're visiting and that you care about them. When we have guests, it's usually for a very relaxing, hours-long meal. On the following pages is our idea of a tasting menu that would suit the occasion. (Recipes for each dish can be found beginning on page 166.) The courses aren't big, but they're not small, either. After all, who wants a tiny taste of something great?

We promise this fresh feast will dazzle your guests, whether you make it yourself or give the recipes to your caterer. From Chef Sean's Angus beef sliders with fig jam to his lobster mashed potatoes to his hot dog bun French toast, we've been dreaming about these dishes since we first tasted them.

We also love to be entertained. One of the perks of our job is being invited into other people's homes. These events are often a wellspring of inspiration for us. Recently we were invited to the home of Glen Senk, president of jeweler David Yurman, and husband Keith Johnson, of the Sundance Channel's *Man Shops Globe,* where they treated us to several varieties of Glen's homemade thin-crust pizzas, made from the freshest ingredients—which were by far the best we've ever eaten. We sat around their kitchen counter while he cooked and were made to feel so at home by this dinner, memorable in its simplicity, deliciousness, and warmth.

Previous pages: Highlights from events held at our Signature Stores, at which we partner with local nonprofits and media to create evenings for good causes. *Following pages:* A tasting menu by our corporate chef, Sean Robinson, with photographs of the dishes.

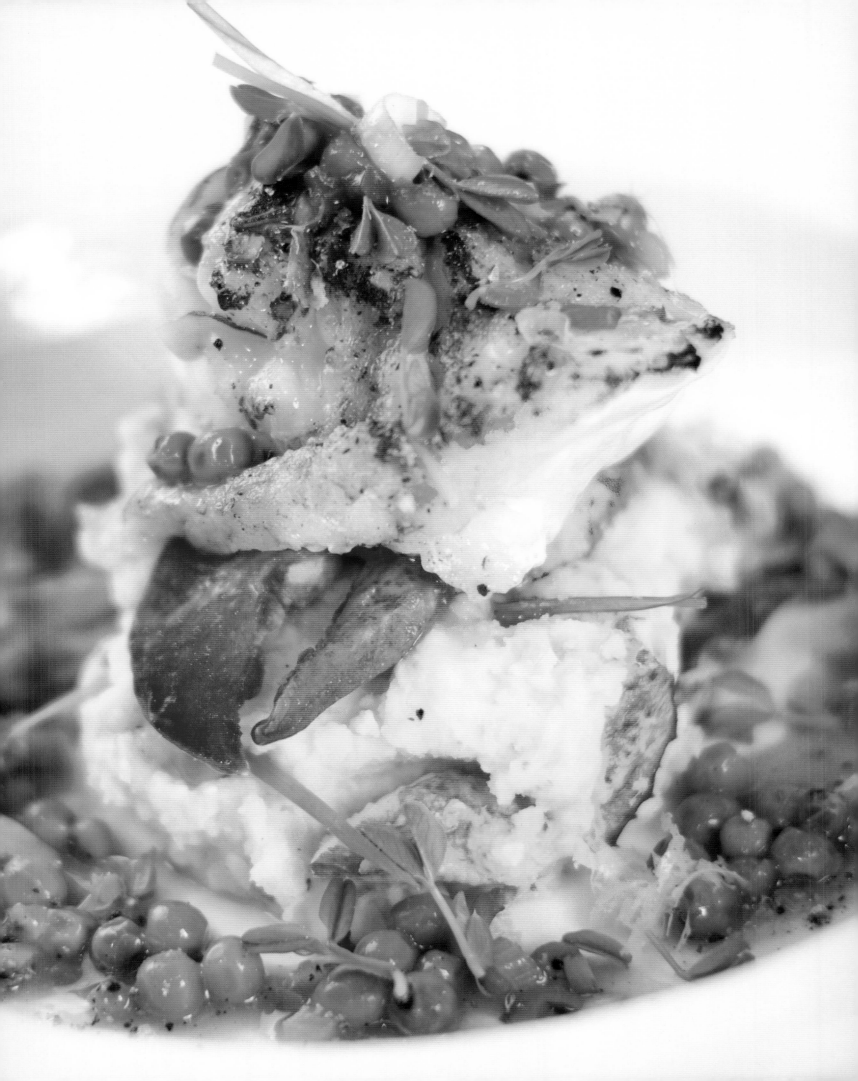

Chef Sean's Tasting Menu

Hors d'oeuvres

Angus Beef Sliders with Aged Cheddar,
Fig Jam, and Baby Arugula on Wheat Buns
Local Cheese and Meat Platter

Soup

Spring Chicken Soup with Meyer Lemon and Multigrain Croutons

Salad

Watermelon, Goat Cheese, Baby Arugula, and Pistachios with
White Balsamic Glaze

Entrée and sides

Pan-Roasted Monkfish with Spring Peas
Lobster Mashed Potatoes

Dessert

Hot Dog Bun French Toast with Fresh Berries and Vanilla Bean Cream

Cocktail

Mitchell's Scotch-tini

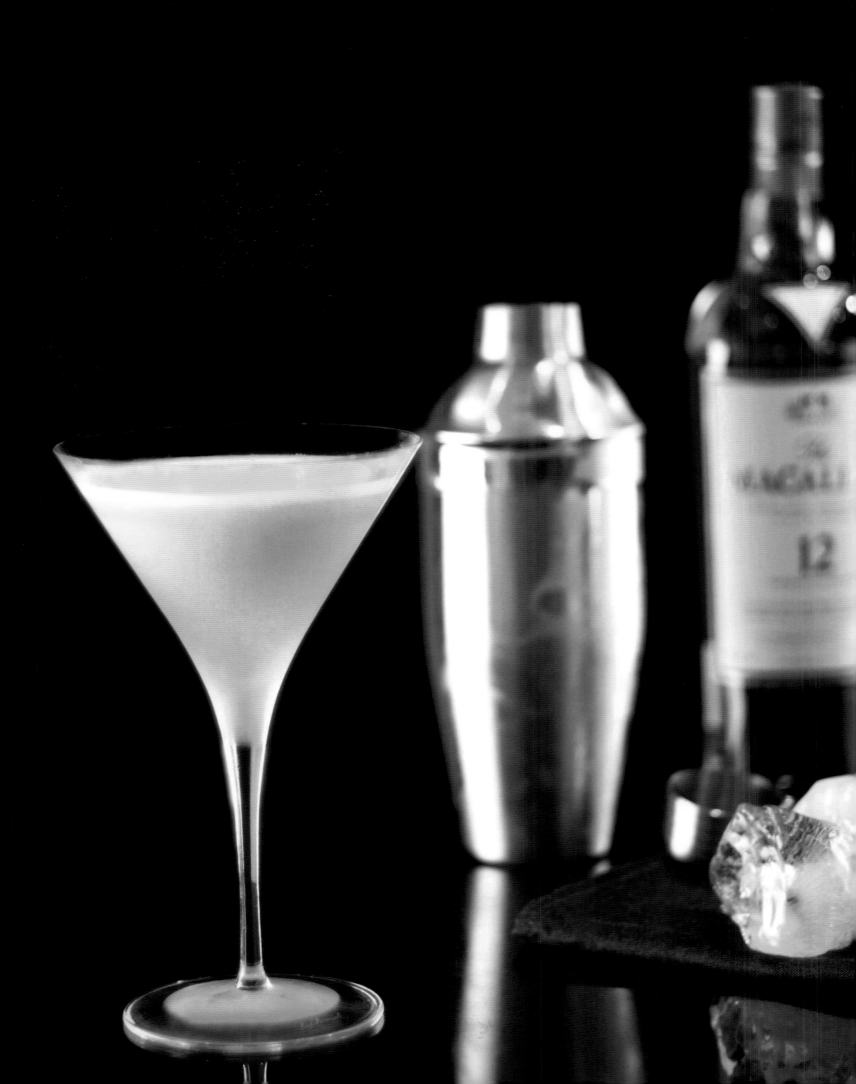

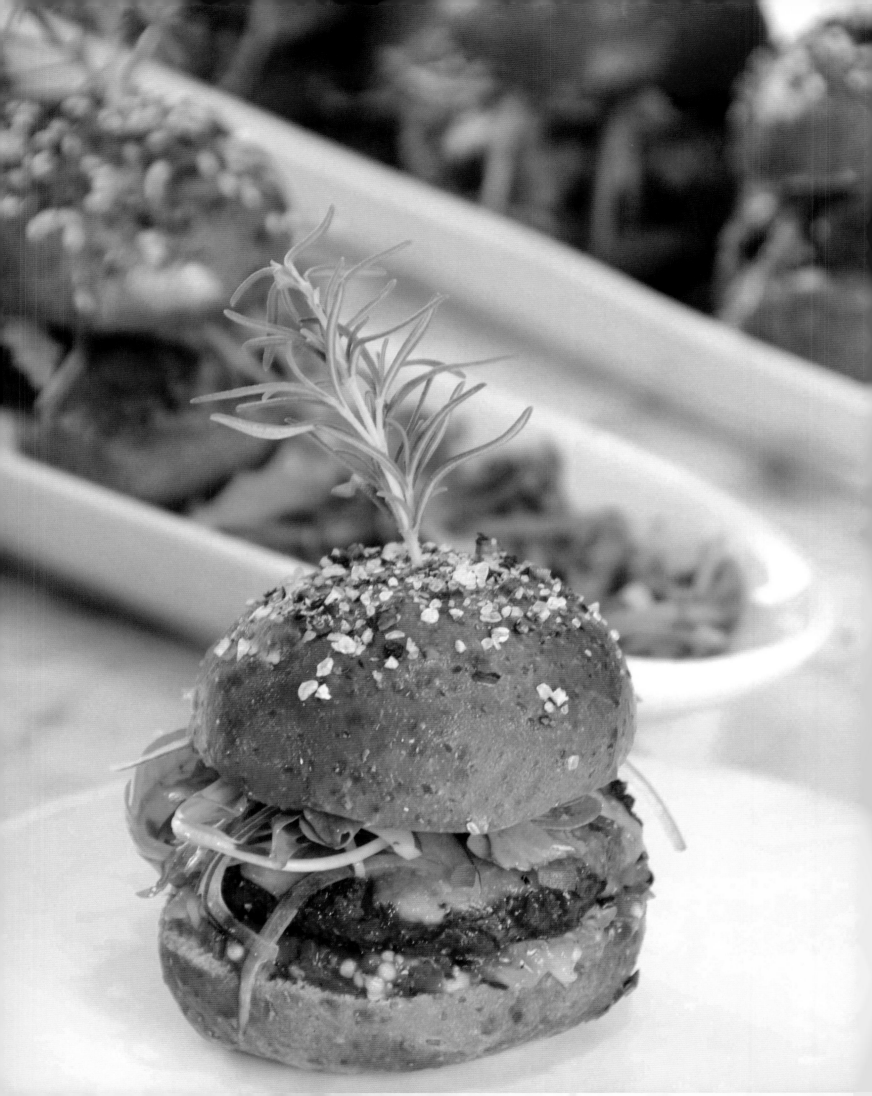

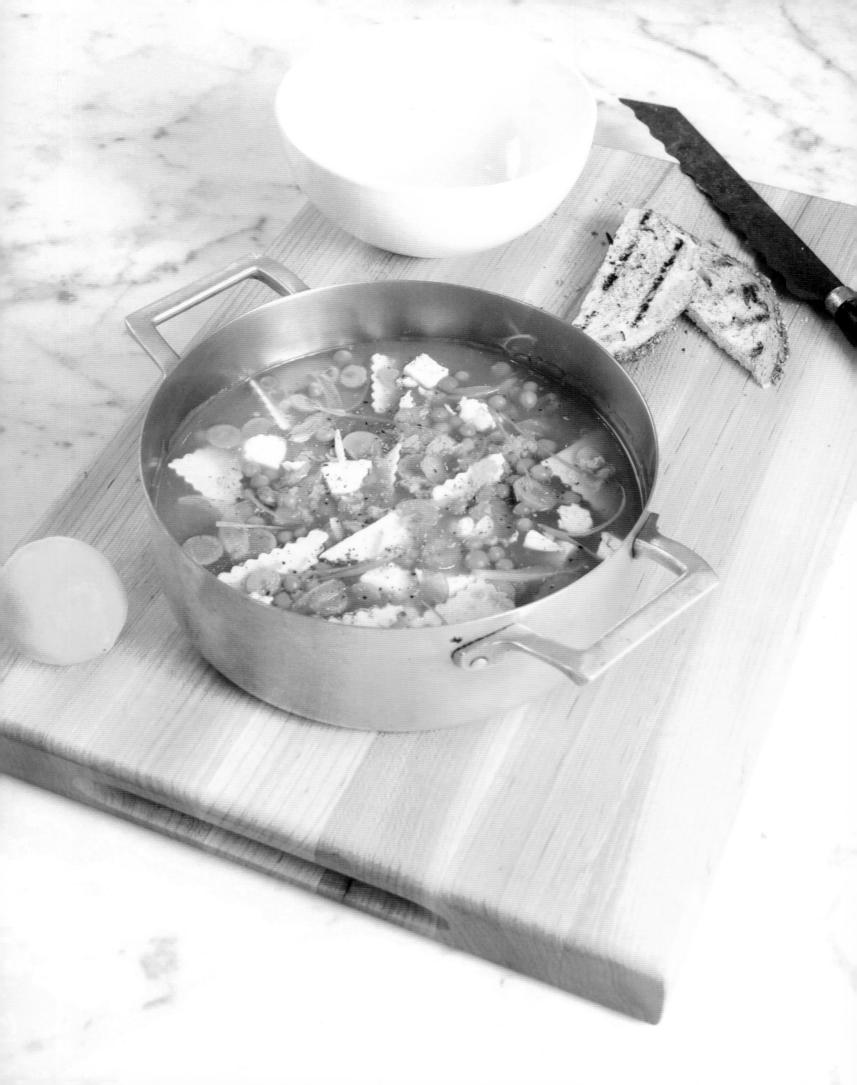

"The courses aren't big, but they're not small either. After all, who wants a tiny taste of something great?"

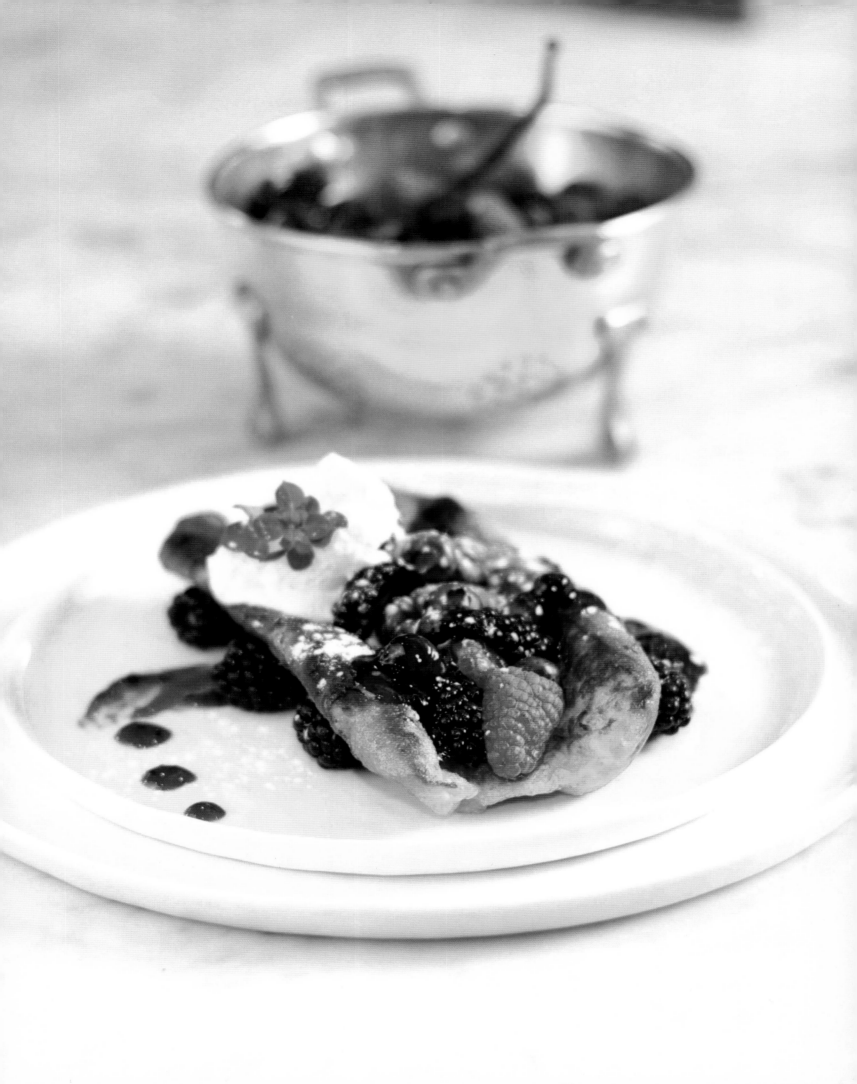

We are *traditional*.

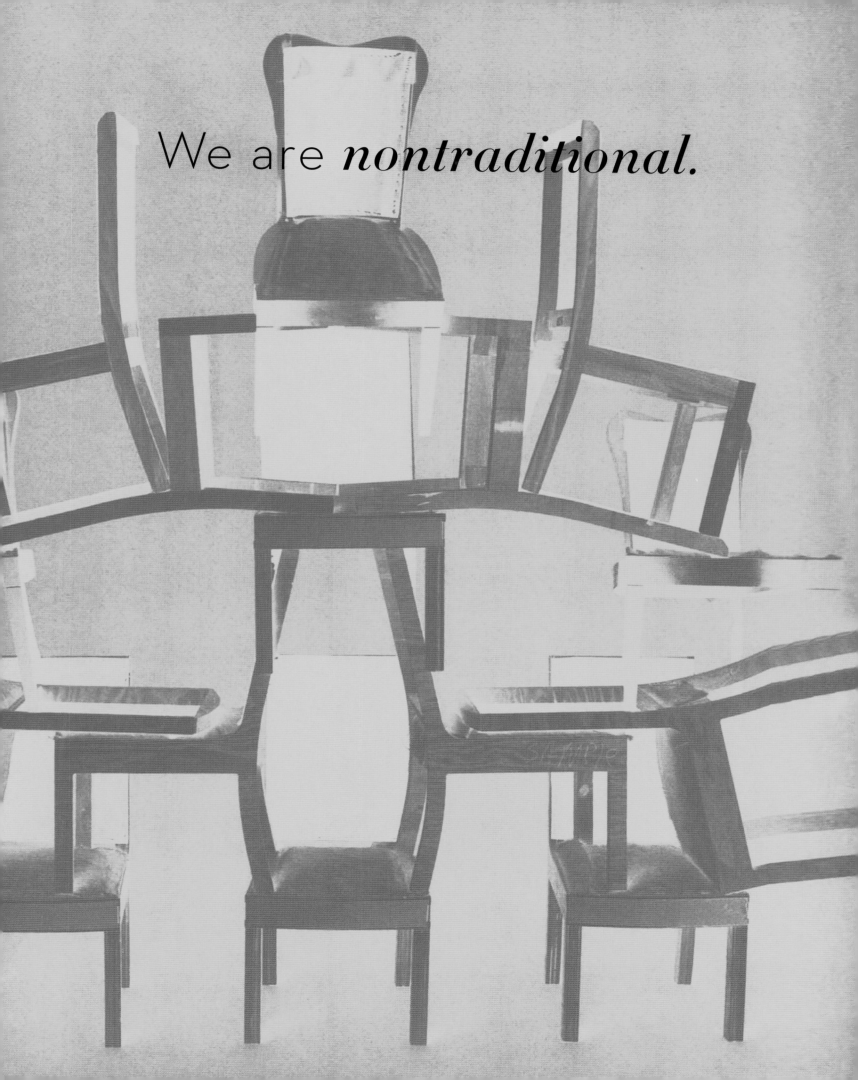

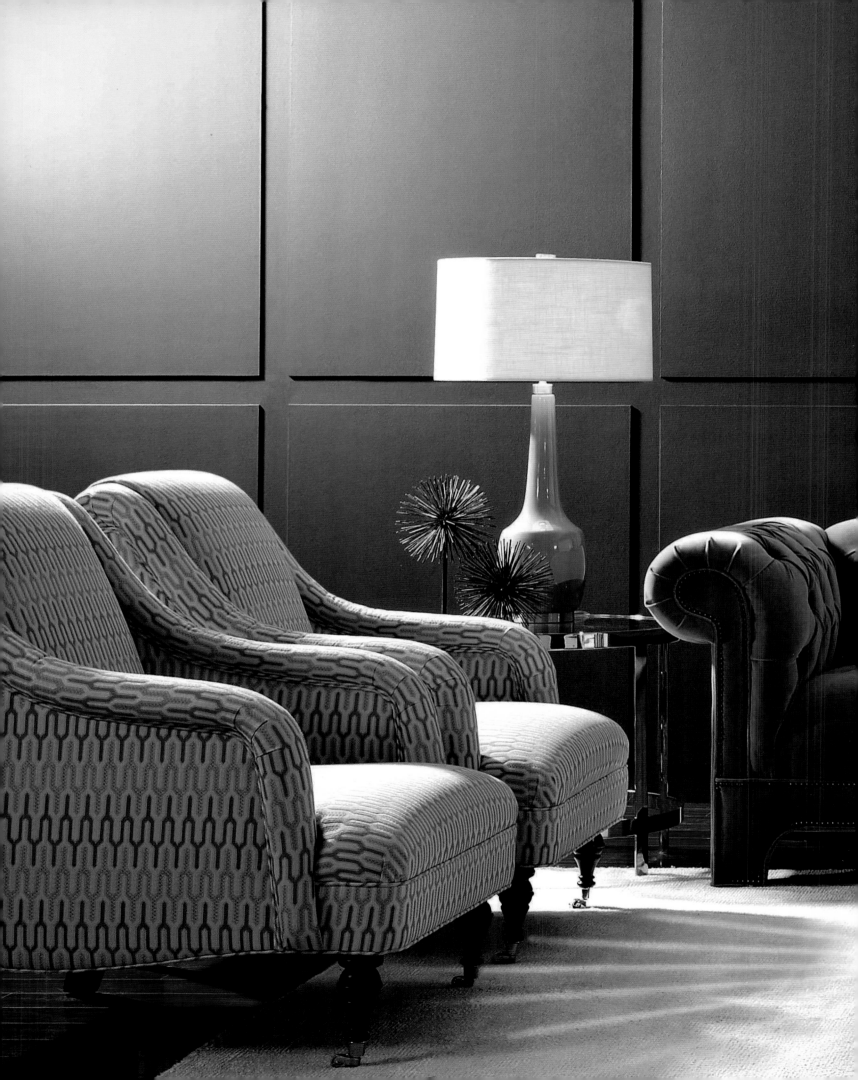

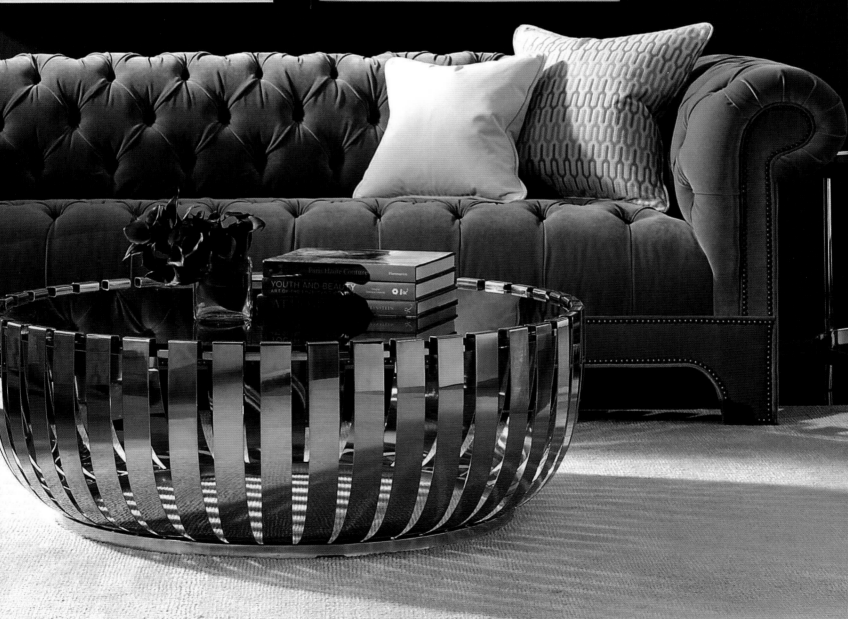

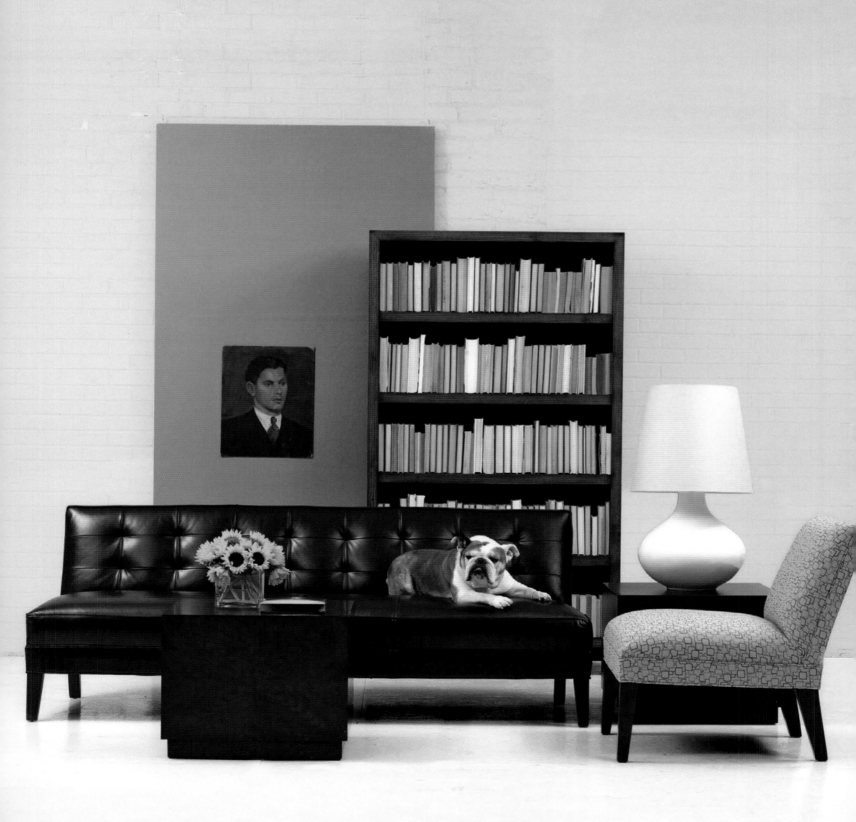

It all started with Relaxed Design: the idea that comfort and sophistication need not be mutually exclusive. Inspired by trends in the apparel industry, we styled our first furniture in soft, washable fabrics like khaki, linen, and denim. These were pieces we wanted in our own homes: classically elegant yet highly livable and exceptionally comfortable. The concept was so successful that it became our signature.

Today we continue to create many traditionally inspired designs reimagined for modern living: Timeless shapes dressed up in unexpected fabrics and patterns. Handsome club chairs generously proportioned for today's more casual lifestyles. Finishing touches that give a room a vintage feel without making it seem stuffy. Sleek modern sofas that are uncommonly cozy. It's that twist that makes our job so much fun. Our product line and aesthetic sensibilities have evolved over the years, but our approach remains the same: "How can it be done? And is it comfortable?"

You'll find traditional and nontraditional influences in the rooms we decorate, as well. In fact, we like to think of decorating more as collecting—the chance to surround yourself with pieces you love, no matter what their era of origin. Creating a beautiful mix of elements like this does several things for you. It makes a room a more personal expression of the people who live in it. It keeps a room from feeling dated too soon. And it gives you the freedom to switch out accessories and accents later for a refreshing change without a full makeover.

Outside of the decorating arena, we're also big fans of the mix. We're traditionalists at heart, always ready to celebrate holidays and life's big and beautiful moments, especially when they involve warm gatherings centered around food. And yet we're all for modernizing when it means a more comfortable way of celebrating with those we love—by fully accepting them, and who they love, for who they are, with all our hearts.

66 We fell in love with this chair partly because we love cars and partly because we love furniture. 99

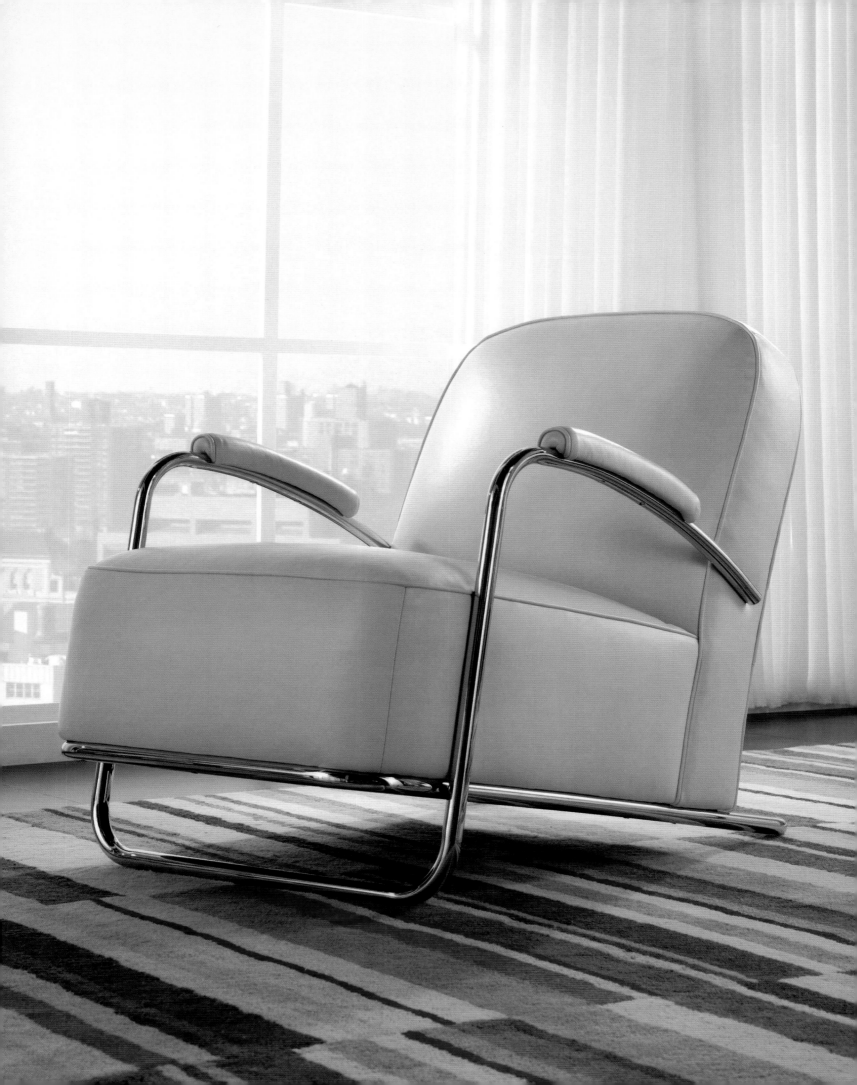

A 2001 ad—our attempt to make recliners cool. This recliner was based on one of our most popular Parisian flea-market chairs. *Pages 134–135:* An image from the *Fast Company* article, "The Gold Standard," 2000. *Pages 136–137:* From our "Let Us Romance You" campaign, fall 2013. Note the sexy Pierre Cardin-inspired Vega cocktail table. *Page 138: A*n outtake from our first book, *Let's Get Comfortable. Previous page:* Our Dean chair in leather.

WHY DO LAZY

"I'll ~~Never~~ Own A Recliner."

RLS LOVE MITCHELL GOLD?

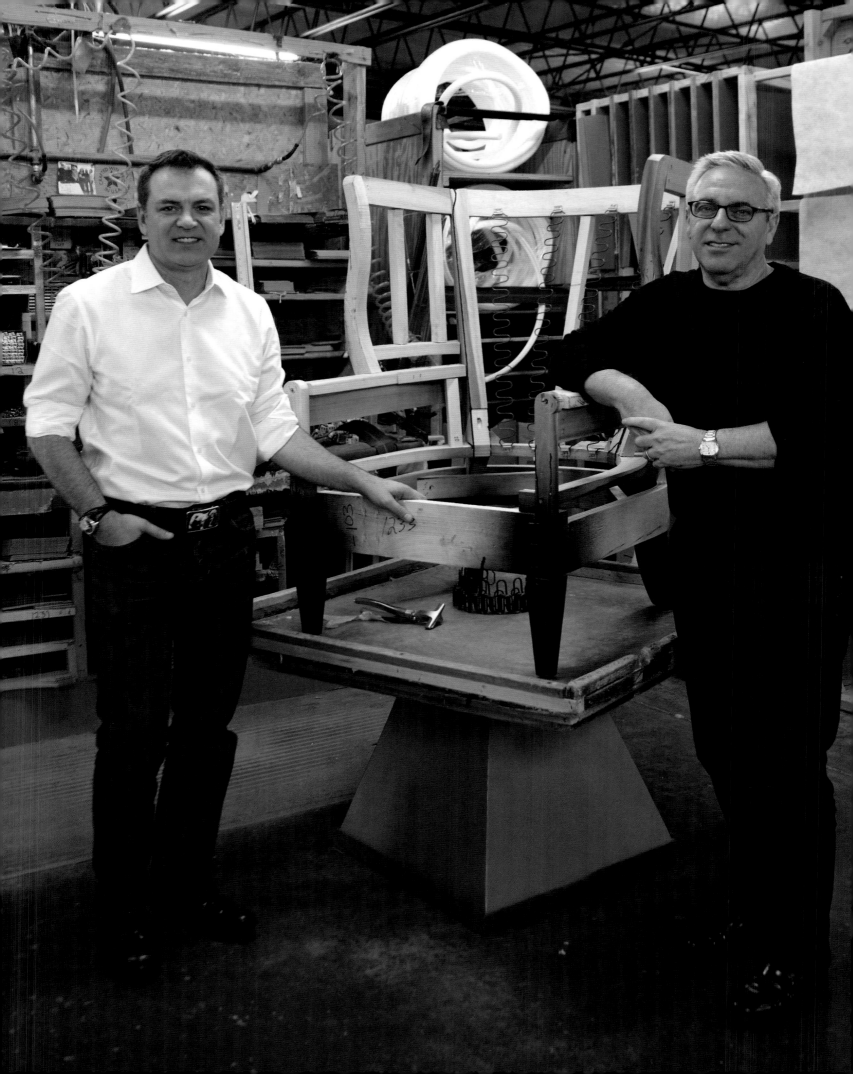

We

love

what we do.

135 One Comfortable Place. That's the address of our headquarters in Taylorsville. Each time we drive down that street we are reminded of the journey that has been the past twenty-five years. Never in our wildest dreams could we have imagined where it would take us.

The phenomenal growth of our company has yielded countless rewards: accolades from the design community, opportunities to meet cultural icons and politicians, and adventures all over the world. But what really makes us lucky is something else. Our business has allowed us to make a positive impact in people's homes as well as in their lives. The benefits we offer our employees, our commitment to good environmental practices, and our partnerships with community advocates are the real perks of this job.

We hope to spend another twenty-five years inspiring others to fill their lives with comfort, caring, and style. Our mission remains the same: to make the world a more comfortable place—for everyone.

On the factory floor in North Carolina.

We never miss a meal.
EVER.

Gathering around to eat a good meal—is there anything better than that? We absolutely love to eat. Not just the part involving food, but the ritual itself.

When something scrumptious arrives at the table, the mood in a room suddenly lightens. The conversation gets richer. In that moment, the whole day's worries disappear. That is the true meaning of comfort, if you ask us.

That food is a great way to forge relationships in our business is something we learned early on. While attending trade shows as customers, we found there was little to eat and few places to sit and enjoy a meal between meetings. At first, in our own trade showroom, we started handing out cookies. Our customers and the press were so appreciative that the following year we began serving a gourmet box lunch. Think chicken potpie and cold poached salmon over cucumber salad. It was a small gesture that made a big impact—our customers and those editors never forgot us.

Today, food is an integral part of our company culture. For that we can thank our enormously talented and visionary company chef, Sean Robinson. With his help, we turned our factory's cafeteria into something extraordinary.

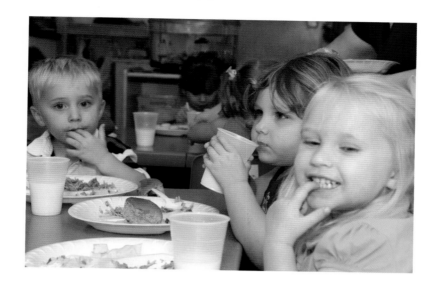

Café Lulu opened in 1999 with a simple idea: to provide healthy and tasty meals at a reasonable price. Chef Sean regularly shops at the area's farmers' markets to create his daily menus. He always offers a vegetarian and low-carb option and excels at making healthy food both satisfying and delicious.

Chef Sean has orchestrated countless feasts for our clients, the press, and friends, as well as our employees and the kids in our day-care center. We've learned a lot from him about how a kitchen should function, whether you're cooking for two or fifty.

And one more thing: Sitting down to a great meal together has additional benefits. It's important from a health perspective as well as for the happiness boost that celebrating life's special occasions brings. And, judging by its effectiveness in business, we even feel our world leaders would benefit from having more casual meals together. This reminds us of the conversation starter "If you could have dinner with anyone in history, who would it be?" For Mitchell's dream dinner, he would invite Jesus, along with several leaders from today's clergy who use their interpretations of religious teachings to inflict harm on others. Imagine the results.

Chef Sean's yummy whole-wheat spaghetti and veggies for lunch at the day-care center.

We create an environment of
MUTUAL RESPECT.

"I came into the company with no experience in furniture or human resources but was given opportunities and put into places where I could learn. That cultivates a different kind of environment—one with a lot of loyalty and many long-term employees." —Dan Gauthreaux, vice president of human resources

"Respect" is the word Mitchell's father, Jack, used when he first taught him the concept of racial equality. That people's differences should be appreciated and that everyone deserves fair treatment are principles we have never forgotten. Today our company culture is guided by those simple ideas. We recognize that each person who works for us has unique needs, talents, and ambitions. Some of our employees have young children. Some are trying to quit smoking. Others might work in accounting but aspire to work in marketing. All these people work incredibly hard, every day, to meet our needs as a company. So we strive to address their needs and aspirations as well.

"Respect is a two-way street. Employers have to set the example and take the first step."

Here's how we do it: We invest in our employees. By nurturing talent and usually promoting from within, we offer people the opportunity to grow professionally and achieve a greater sense of satisfaction from their work.

We offer many benefits. Based on our belief that people should have a great work environment, in all areas, we have a health-conscious café, a gym, a walking track, an annual health fair, and a day-care center (that isn't just babysitting). We have an on-site nurse. We clean the bathrooms in our factory twice a day.

We provide comfort. Not only do we ensure that working conditions are above industry standards, but we also make life easier for our employees in a variety of other ways. The Comfort Zone is a concierge service we created in 1998 to help them save time during the workweek. For a small fee, we will arrange to have their dry cleaning picked up or their car serviced. They can purchase birthday cards, balloons, and gifts for important occasions. There's a lending library. And they can access the Internet on computers—something not all employees can do, or can wait to do, at home. We also installed the first ATM machine in the county at our factory, so they wouldn't have to waste a lunch break standing in line at the bank.

We truly respect our employees. And they respect us back. That helps make going to work each day a rewarding experience for everyone. Our hope is to inspire other companies to establish similar policies and benefits.

Previous pages, left: Scenes from our factory life, from health care and day care to healthy eating, education, and exercise. *Following pages:* Easily the most heartwarming day of the year is our day-care graduation ceremony, complete with miniature caps and gowns, great guest speakers, and happy parents.

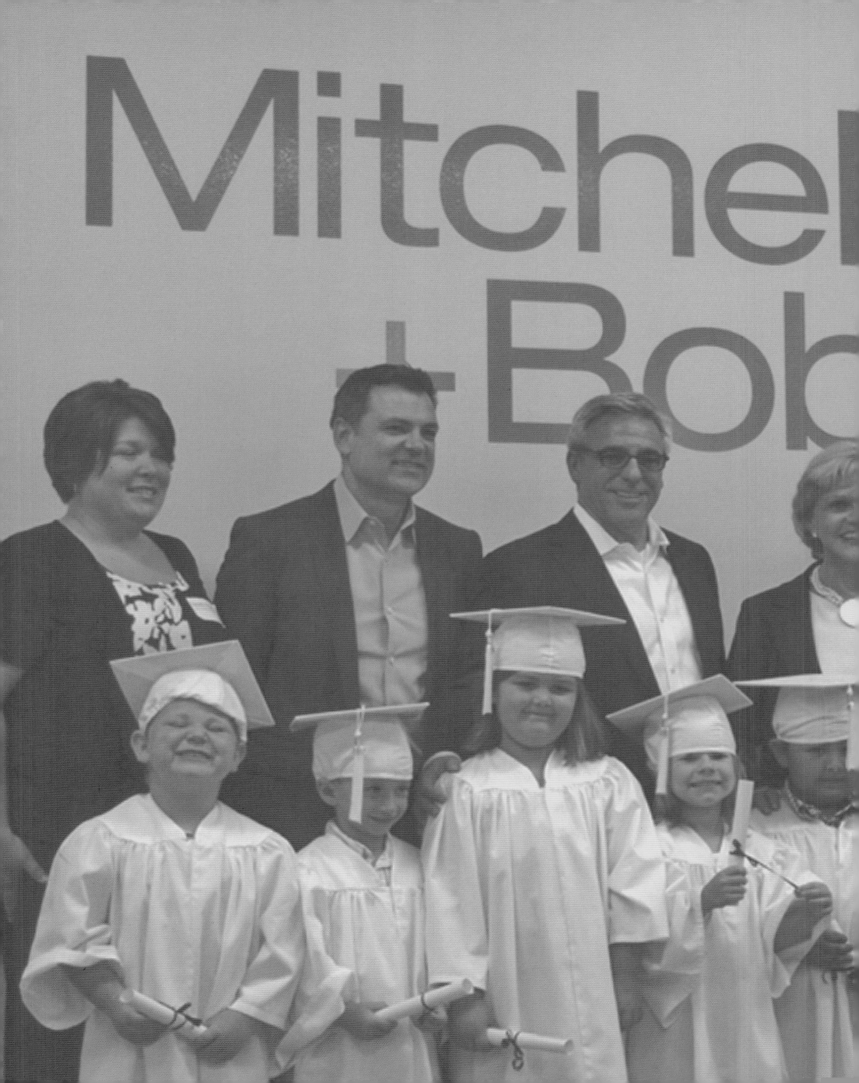

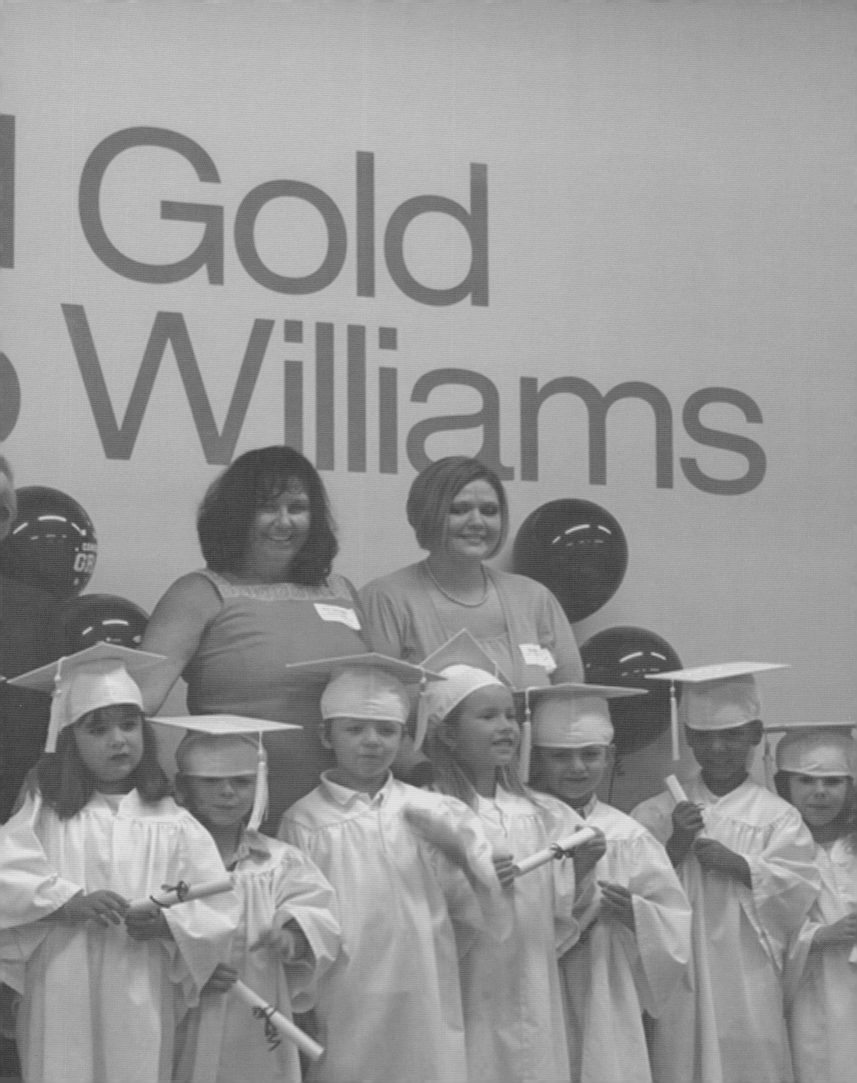

We respect our environment

In 1989, Mitchell read a front-page article in *The New York Times* about the depletion of the ozone layer. It cited North Carolina's furniture industry as one of the biggest contributors to the problem. Manufacture of petroleum-based foam used in seat cushions was emitting CO_2 into the atmosphere. Mitchell ran to a telephone booth (this was before cell phones) and called Bob. "You are not going to believe this," he said, "but we are starting a business that's one of the biggest abusers of the environment. What can we do?"

We immediately set out to find an alternative kind of cushion foam. Serendipitously, a new company had just started manufacturing foam that did not emit CO_2. We became one of its first customers. This prompted us to think about other things, from the wood used in our upholstery frames to our packaging materials. We got on a green kick—although few in the furniture business were calling it green in those days.

Some people thought we were a little crazy. However, in addition to letting us sleep well at night, our eco-friendly practices were resonating with consumers. While visiting a store we sold to in Cambridge, Massachusetts, we overheard a salesperson tell a couple with a young boy that our chairs were "environmentally responsible." Their son, who was about six or seven years old, declared, "That's good! They're teaching us to recycle in school."

Our commitment to environmental sustainability has been good for the bottom line. But for us, it's common sense. We always try to do the best we can. And we loved getting recognized for it with a gift from Vice President Al Gore honoring our commitment to the environment.

An award from former Vice President Al Gore recognizing our commitment to the environment. *Opposite:* The perfect graphic from our plant-a-tree campaign with nonprofit Trees for the Future.

We believe in providing customers with a value.

We

value

our

customers.

"Whether it's one of our regional account managers (RAMS) working with the small and highly select number of retail stores we sell to, or one of our design associates working with a consumer, our emphasis is on taking care of them extremely well. We train our team so that consumers feel safe and satisfied buying from them." —Mitchell Gold

We want customers to feel good about their purchases. We don't pressure them to buy things they don't actually need. We make every effort to respect their time and budget. Products are reasonably priced, not grossly marked up.

To keep prices in check, we work tirelessly to limit the cost of production without sacrificing quality. For example, we spent years researching different springs to use in our upholstered chairs and sofas. Prevailing wisdom was that labor-intensive, eight-way-hand-tied springs were best; unsurprisingly they were the most expensive. After some experimenting, we discovered that new types of cushion foam worked well with steel serpentine springs. Not only were the springs less costly, but they were faster to assemble and easier to repair. The result was equal if not superior comfort and durability. Thinking differently paid off.

We recognize that our customers' time is valuable, so we streamlined the entire shopping experience. Every minute spent browsing the catalog, shopping in our stores, or visiting our Web site counts, so we provide all the information they need right there. Design associates and "live" customer-care representatives are always on hand to answer additional questions.

Our mantra is simple: Treat all customers as we would want to be treated ourselves.

Following pages, right: Snapshots from our travels. *Page 161:* Our most recent collection features influences as diverse as John and Yoko's white suits to Biba, a 1970s-era London store and artist's mecca, and mid-century homes in Los Angeles.

We are

curious

about everything.

Behind Bob's desk are several different "inspiration" baskets. Each is brimming with travel ephemera, clippings from magazines and books, printouts from the Internet, menus, sketches, swatches—you name it. It's probably no coincidence that the "Next House" basket is filled with the most stuff. We have always designed products that we'd want in our own homes—even homes we don't own yet.

Inspiration can come from anywhere, so we collect things along the way. A color arrangement in a wildflower garden might inspire a fabric—or a trip to the South of France would lead to a new mix of hues for a room. A vintage typeface might inspire the sleek lines of a chair. Putting together the look of our showroom gives us an excuse to watch an old movie. A period in history might inspire a whole collection. And the things we collect and the places we travel to find them do more than inspire our designs; they help guide how we live. We are big believers in the idea that if your eye is drawn to something, it's drawing you in for a good reason.

"We watch pop culture carefully because it gives us good clues into what will resonate with consumers in the future."

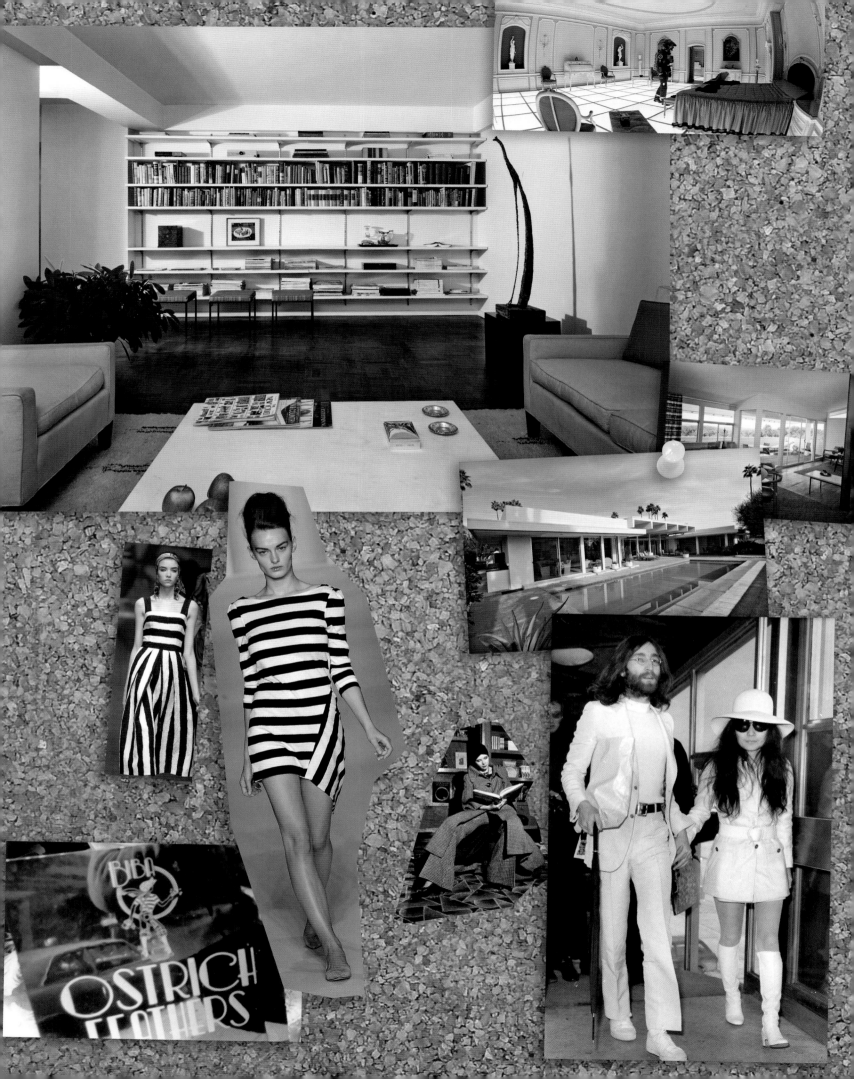

1989

We start DesignLine, Ltd. to manufacture dining chairs and eclectic dining tables.
We expect to have twenty-five customers and work four days a week, but Mitchell pre-sells five thousand dining chairs and eight hundred dining tables before the factory opens. So much for working four days a week.
We initiate environmentally intelligent practices for design and manufacturing.
Lucy upholstered dining chair makes an appearance.
By December DesignLine, Ltd. has twenty-three employees.

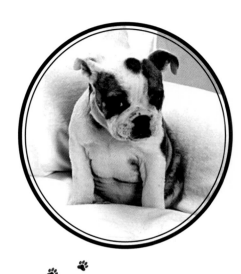

1988 BC *(Before Comfort)*

1990–1991

1992–1994

1995–1996

The economy is in a tailspin: unemployment and interest rates are up, the GDP and Dow Jones are down. During this turbulent time we deliberate between starting a small furniture company in North Carolina or a Christmas tree farm in Virginia.

First annual employee health fair.
Collection expands to include occasional chairs.
We reach $1 million in sales in the first full year.

Lulu is born.
www.MitchellGold.com launches.
Ad campaign: Clay, Lulu, and Kathleen (first provocative ad).

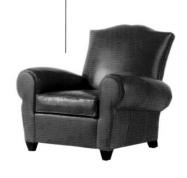

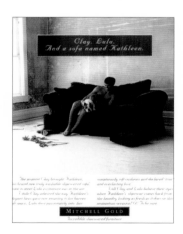

DesignLine, Ltd. becomes The Mitchell Gold Co.
We start making sofas.
Our Parisian leather club chairs hit the scene.
We make a velvet chaise for Cher's Goth-inspired catalog, *Sanctuary*.
Ad campaign: It's Not for Everybody (our first national ad).

Starbucks chooses our comfortable chairs for their cafés. Epic 10th anniversary party in High Point, North Carolina. Lulu's Child Enrichment Center opens with thirty-four children. Café Lulu opens, offering healthy menu options.

1999

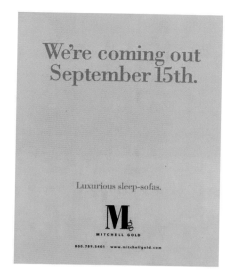

2000

Featured in *Fast Company*: "The Gold Standard."
Featured in *Esquire* magazine: "The Midas Touch."
Luxe sleepers make their debut.
Ad campaigns: A Kid Deserves to Feel at Home and We're Coming Out.

Corporate-owned shop-in-shop opens in New York at ABC Carpet & Home.
Licensed Signature Stores open in Portland, Ann Arbor, and Seattle.
The Mitchell Gold Co. forms a partnership with Wafra Partners, LLC, to buy the company back from Rowe.
Dr. Pitt sectional introduced.

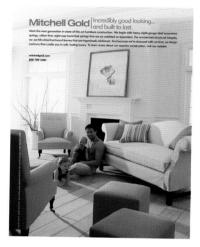

1997–1998

2003

State-of-the-art factory opens at 135 One Comfortable Place.
The Mitchell Gold Co. is sold to Rowe Furniture.
Featured in *The Wall Street Journal*: "Furniture Maverick."
Ad campaign: Introducing Platinum.

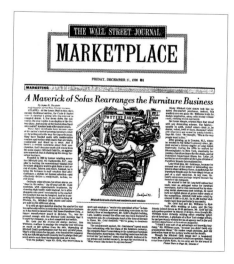

2001–2002

Featured in *Time* magazine: "Gold's New Rush."
Featured in *Health* magazine: "The 10 Best Companies for Women."
Ad campaign: Why Do People Love Mitchell Gold?

2004

Licensed Signature Stores open in Los Angeles, Boston, Indianapolis, and Newport Coast, California.
Charlie Rose interviews Mitchell.
Alex collection introduced.
Our contract division, Mitchell Gold + Bob Williams Hotel, launches.
We receive *Out* magazine's Voices of Style + Design award.
Ad campaign: Incredibly Good Looking and Built to Last.

First international licensed
Signature Stores open in
Mexico City and Toronto.
Licensed Signature Store opens
in Puerto Rico.
Our first Tipper Gore
photography exhibit.
Rugs and accessories are
introduced to the line.
Featured in *The Advocate*:
"Giving Gold with Creech."
We receive one of *Out* magazine's
People of the Year awards.
Ad campaign: We Fell in Love...

2006

Our first book, *Let's Get
Comfortable*, is published.

Corporate Signature Store opens
in Greenwich, Connecticut.
Licensed Signature Store opens
in Houston.
Mitchell's book, *Crisis*, is released.
On-site nurse and employee-wellness
program are initiated.
Ad campaign: Our Model. Exposed.

2005

2008

Licensed Signature Store opens in Atlanta.
The Mitchell Gold Co. becomes Mitchell
Gold + Bob Williams.

Mitchell Gold
+Bob Williams

Featured in *INC* magazine:
"Entrepreneurs We Love."
Mitchell Gold + Bob Williams Too,
our factory in Hiddenite,
North Carolina, opens, bringing
us to more than 500,000 square
feet of factory/office space.
First collection of case goods and
lighting launches.
We host our Sweet 16 anniversary
party in High Point, North Carolina.
Featured in *Elle Décor*: "Striking Gold."
Featured in *Country Home*:
"Relaxed Pedigree."
Mitchell forms Faith in America.

2007

Licensed Signature Stores open
in Miami, Nashville, and Natick,
Massachusetts.
Corporate Signature Stores open in
New York City and Washington, D.C.
First feature on NBC's *Today* show.
Featured in *The New York Times*:
"Amicably Split, and Still Sharing."
First consumer catalog is mailed out.
Our lovable Lulu passes away.
Ad campaign: We're Modern.
Traditionally Speaking.

We celebrate our twentieth anniversary.
Our second book, *The Comfortable Home*,
is published.
The Stonewall Community Foundation
presents Mitchell with their Visionary Award.
Ad campaign: Undeniable:
Beauty + Comfort + Value.

Licensed Signature Store
in Boston expands.
Segment on *CBS Sunday Morning*.
Featured in *Lonny Magazine*:
"The Gold Standard."
Mitchell and Bob's New York
apartment is photographed in
New York Cottages & Gardens.
Collection for CBS's *The Good Wife*
is introduced; the first furniture
license in TV history.
Interfaith Alliance honors Mitchell
with the President's Award for
Defending Faith & Freedom.
E-commerce is launched.
Luxe bed linens are introduced.

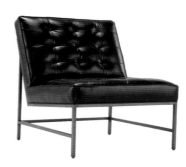

2012

2009

2013

2014

2010

Corporate Signature Stores open
in Portland and South Coast Plaza
Village in Orange County, California.
Licensed Signature Store opens
in Dallas.
We receive the Divine Design
Interior Award from Project
Angel Food.
Our super luxe sleeper wins
the hotel industry's Editor's
Choice Award.
We join Facebook and Twitter.

Corporate Signature
Stores open in Houston,
Beverly Hills, Paramus,
New Jersey, and
Manhasset, New York.
Licensed Signature Store
in Mexico City reopens
under new ownership.
Mitchell appears on the
TV show *Joy Behar: Say
Anything!*

2011

Corporate Signature Store opens
in Chicago.
The Washington Post features
Mitchell and Tim's D.C. condo.
Traditional Home features Bob's
house in North Carolina.
Major chair is introduced.
Manning collection is introduced.
Mitchell's book, *Crisis,* is published
in paperback with a new title,
Youth in Crisis.
Bob's French bulldogs, Lily and
Violet, join the family.

Corporate Signature Stores
open in Miami and Tyson's
Corner, Virginia.
Our 25th anniversary!

Recipes

Angus Beef Sliders with Aged Cheddar, Fig Jam, and Baby Arugula on Wheat Buns

SERVES: 8
PREP TIME: 25 MINUTES
COOK TIME: 20 MINUTES
DOABLE IN ADVANCE:
MAKE FIG JAM. SLICE,
GARNISH, AND TOAST ROLLS.
SKILL LEVEL: EASY

1 medium sweet onion, diced
1 clove garlic, minced
1 tsp. extra-virgin olive oil
1/2 lb. fresh figs, diced
2 oz. water, divided
1/2 cup sugar
1 tsp. mustard seed
8 whole-wheat dinner rolls
1 egg
1 Tbsp. sesame seeds
1 Tbsp. fresh chives, minced
1 1/2 lb. ground lean 90/10 Angus beef
1 Tbsp. Worcestershire sauce
Salt and pepper
6 oz. aged white Cheddar
1 oz. baby arugula

Fig jam: In a small pot over medium heat, cook onion and garlic in 1 tsp. olive oil until onion starts to become translucent. Add figs, 1 oz. water, sugar, and mustard seeds. Cook 10 minutes, stirring so the jam doesn't stick. Remove from heat and cool. Store in refrigerator. This can be made up to 3 days in advance.

Toasted buns: Preheat oven to 350°. Slice rolls in half and lay on sheet pan, cut side down. Crack egg into small bowl and add 1 oz. water. Beat until smooth. Lightly brush egg mixture onto top of each roll and sprinkle sesame seeds and chives over each. Bake for 5 minutes and set aside.

Burgers: In a mixing bowl, add ground beef, Worcestershire sauce, and salt and pepper to taste. Mix until incorporated and form into 8 patties, approximately 3 inches in diameter. Preheat grill on high heat. Cut Cheddar into 8 slices. Grill patties for 5 minutes on each side (or less, depending on degree of doneness desired). Place a Cheddar slice on each patty after grilling on first side, to allow cheese to melt. Build sliders on wheat rolls with fig jam and baby arugula on each. Serve warm.

Local Cheese and Meat Platter

Note from Chef Sean: I believe it's our responsibility to use local ingredients whenever possible to support farmers, artisans, and the local economy. Locally grown products usually taste better, are often more wholesome than store-bought ones, and can be less expensive. Visit a farmers' market or creamery near you. Mingle, taste, and ask questions. I always ask the artisan/farmer what's ripe and which cheeses are "ready" for market.

Remember that a contrast of textures, tastes, colors, shapes, and sizes works well—earthy and sweet, creamy and salty, and some crunch from nuts and crackers. The more you try new things, the more you'll know what you like and feel passionate about. And that is key to a successful platter.

For the platter in the photographs, I used:

CHEESES
New Moon – semi-ripe cow's brie (Chapel Hill Creamery, Chapel Hill, North Carolina)
Chevre – fresh goat cheese (Goat Lady Dairy, Climax, North Carolina)
Gray's Chapel – half goat & half cow cave-aged cheese (Goat Lady Dairy, Climax, North Carolina)
Chesapeake Blue – goat blue cheese, wrapped in fig leaf (Bonnyclabber Cheese Co., Wake, Virginia)

MEATS (ALL FROM SAN GIUSEPPE SALAMI CO., GREENSBORO, NORTH CAROLINA)
Milano-style dry salami
Hot soppressata
Prosciutto di Parma

PAIRINGS
Locally grown figs and champagne grapes
Nuts and crackers

Before serving, unwrap meats and cheeses to let them breathe. Serve platter at room temperature. A well-laid-out platter is like a work of art, so creativity in arranging and slicing/dicing/rolling is welcome. One suggestion: Guests will appreciate it if you group all the meats and all the cheeses together, and arrange the cheeses with the strongest farthest from mildest.

Spring Chicken Soup with Meyer Lemon and Multigrain Croutons

SERVES: 8
PREP TIME: 25 MINUTES
COOK TIME: 30 MINUTES
DOABLE IN ADVANCE: CROUTONS
CAN BE MADE UP TO A DAY EARLY.
SKILL LEVEL: MODERATE

1 multigrain baguette
Extra-virgin olive oil
Salt and pepper
1 lb. chicken breast
3 qt. organic low-sodium chicken broth
8 oz. whole wheat wide egg noodles
1 each carrot, leek, small red onion, diced
2 cups baby green peas
2 Meyer lemons

Croutons: Slice baguette into 1/4-inch slices on the bias, brush with olive oil, and lightly salt and pepper. Grill over medium-high heat to toast, approximately 30 seconds on each side.

Soup: In a large soup pot on medium-high heat, add 1 tsp. olive oil and chicken breast. Allow chicken to cook 5–7 minutes on each side until an internal temperature of 165° is reached. Remove chicken from pot and set aside. While pot is still on heat, pour in chicken broth and scrape brown bits off bottom with spoon. Allow broth to come to a boil and add egg noodles. Stir noodles for several minutes so they do not stick together. Then add diced vegetables and continue cooking about 15 minutes (or until vegetables reach desired tenderness). Cut cooked chicken breast into bite-size pieces. Add to pot along with peas. Zest one lemon and juice both lemons. Add zest and juice to pot. Cook soup on medium heat for an additional 15 minutes. Add salt and pepper to taste. Serve hot in bowls with grilled croutons.

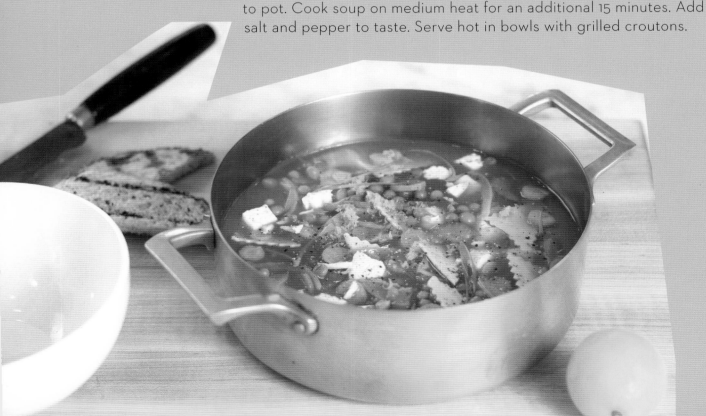

Watermelon, Goat Cheese, Baby Arugula, and Pistachios with White Balsamic Glaze

SERVES: 8
PREP TIME: 30 MINUTES
COOK TIME: 20 MINUTES
DOABLE IN ADVANCE:
CRUSH PISTACHIOS. ROLL GOAT-CHEESE
BALLS AND REFRIGERATE. MAKE WHITE
BALSAMIC GLAZE.
SKILL LEVEL: MODERATE

1 cup white balsamic vinegar
1 oz. honey
1 lb. fresh chilled goat cheese
2 oz. pistachios, shelled, roasted, and salted
1 ripe watermelon
1/2 lb. baby arugula
2 oz. shaved red onion, thinly sliced on
an angle
Extra-virgin olive oil
Salt and cracked black pepper

Balsamic glaze: In a small pot, reduce vinegar and honey by 1/2 on medium heat (about 15 minutes). Allow the balsamic glaze to cool before use.

Cheese balls: Roll chilled goat cheese into 1/2-inch balls, enough for 3 per plate. Refrigerate until needed.

Salad: Use a mallet or bottom of a pan to crush pistachios into smaller pieces. Cut watermelon into 3/4-inch cubes, enough for 5 pieces per plate. Last minute before serving, place arugula and shaved onion into bowl and drizzle with olive oil. Toss to coat leaves. Arrange arugula, watermelon, and cheese balls on each plate, sprinkle with pistachios, drizzle with balsamic glaze, add salt and pepper to taste. Serve immediately.

Pan-Roasted Monkfish with Spring Peas

SERVES: 8
PREP TIME: 20 MINUTES
COOK TIME: 15 MINUTES
SKILL LEVEL: MODERATE

4 cups fresh English peas
(or frozen, if not available)
2 lbs. fresh boneless, skinless
monkfish
Salt and pepper
2 oz. extra-virgin olive oil
1 shallot, diced
3 garlic cloves, minced
1 1/2 cups dry white wine
Fresh basil

If using fresh peas, bring salted water to a simmer. Blanch in simmering water for 1 minute, remove, and chill in cold water. If using frozen peas, defrost, and skip blanching process.

Cut monkfish into 4-oz. pieces and lightly salt and pepper. Place large sauté pan on medium-high heat and allow pan to heat fully. When pan is hot, carefully add olive oil and place fish spaced evenly into pan. Cook 4 minutes on each side. Take fish out of pan; allow to rest on side plate. Place same pan on heat and add peas, shallot, and garlic. Sauté 3 minutes. Deglaze pan with white wine while stirring mixture for 1 minute. Add basil and salt and pepper to taste. Place fish on serving plate and top with sautéed peas and basil.

Lobster Mashed Potatoes

SERVES 8
PREP TIME: 20 MINUTES
COOK TIME: 1 HOUR
**DOABLE IN ADVANCE: A FISHMONGER
CAN STEAM YOUR LOBSTER TO SAVE YOU
TIME; MOST WILL BE GLAD TO OBLIGE.**
SKILL LEVEL: MODERATE

2 2-lb. steamed lobsters
1 cup yellow onion, chopped
1 cup celery, chopped
1 leek, chopped
1/4 lb. unsalted butter, softened and
divided
3 tsp. sea salt
3 lbs. russet potatoes, peeled
1/2 cup scallions, chopped
1 tsp. garlic, minced
1 cup heavy cream
Sea salt and freshly ground black pepper

Lobsters: Steam if you are unable to have them steamed when you buy them. Let cool. Take lobster meat from shells and set aside. Also set aside shells to use in making lobster stock.

Lobster stock: In stockpot, sauté onion, celery, and leek in a little butter until onion is translucent. Dice lobster meat into bite-size chunks, and reserve. Add lobster shells to pot. Fill with water until shells are covered. Bring to a simmer; let simmer 45 minutes.

Mashed potatoes: Strain stock from shells into pot in which you will boil potatoes. Mix 3 tsp. of sea salt into stock. Add potatoes and boil until soft. Strain potatoes and mash in pot. Add scallions, garlic, and lobster to hot potatoes. Stir in remaining butter and cream until well blended. Salt and pepper to taste.

Note: "The secret is in not being stingy with the lobster." —Mitchell

Hot Dog Bun French Toast with Fresh Berries and Vanilla Bean Cream

SERVES: 8
PREP TIME: 20 MINUTES
COOK TIME: 20 MINUTES
DOABLE IN ADVANCE:
WHIPPED CREAM
AND BERRY SAUCE
CAN BE MADE
2–3 HOURS AHEAD
AND REFRIGERATED.
SKILL LEVEL: MODERATE

3 lbs. fresh berries (strawberries, blueberries, blackberries, raspberries)
1 cup local honey
1 qt. heavy cream, divided
1 vanilla bean pod

1 1/2 cups granulated sugar, divided
6 farm-fresh eggs
2 cups whole milk
8 "lite" wheat hot dog buns
4 oz. unsalted butter

Inspiration: "One morning after a barbecue, I wanted French toast. Unfortunately there wasn't any bread among the leftovers, but then Chef Sean saw the hot dog buns and thought their light texture might work. When cooked, the airy buns saturated with egg puffed up into a perfect bread custard. The hot dog French toast with fresh berries was a hit and remains a favorite for brunch or dessert." —Mitchell

Berry sauce: Wash and dry berries. Take 2 cups of mixed berries and place in food processor with honey. Pulse processor until berries are pureed and combined with honey. Place sauce in refrigerator.

Whipped cream: Pour 2 cups heavy cream into bowl of a mixer with whip attachment on. Split vanilla pod and scrape out seeds. Add vanilla seeds and 1/2 cup sugar to cream. (You can save pod and put in a jar with sugar for vanilla-flavored sugar later.) Whip on medium speed until cream forms soft peaks. Reserve in refrigerator.

French toast: Preheat oven to 400°. In large mixing bowl, crack eggs and add remaining heavy cream (2 cups), remaining granulated sugar (1 cup), and milk. Whisk 30 seconds until smooth. Place nonstick pan on medium-low heat. Submerge split hot dog buns in egg mixture until fully saturated, about 20 seconds. Coat hot pan with butter and drop buns facedown onto pan. Cook 30 seconds on each side, then place on greased sheet pan. Repeat until all buns are par-cooked. Place buns in oven for 7 minutes. While buns are finishing, slice remaining larger berries and combine all berries together. Remove buns from oven, place on individual plates, top with berries, drizzle with berry sauce, and top with whipped cream. Serve immediately.

Mitchell's Scotch-tini

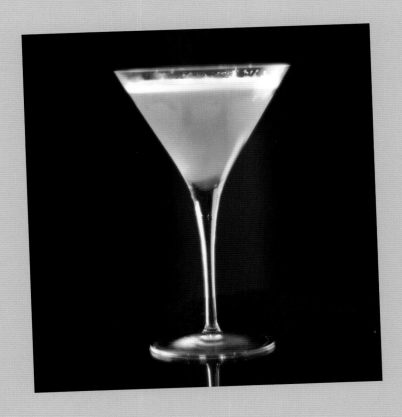

SERVES: 2
DOABLE IN ADVANCE: CHILL MARTINI GLASS IN FREEZER FOR MINIMUM OF 30 MINUTES

8 oz. ice
6 oz. The Macallan 12-year single-malt scotch
Cocktail shaker with strainer
Martini glass, chilled

Put ice into shaker, add scotch, and shake vigorously for 30 seconds so that there will be froth on top when the drink is poured. Pull martini glass out of freezer at the last second and quickly strain shaken scotch into glass. Serve immediately.

Note: The ice and vigorous shaking are key. They create the froth and tiny ice crystals on top. Keep in mind that this is a strong drink.

Acknowledgments

It is not easy to capture the DNA of a living, breathing twenty-five-year-old company in a book. We were helped and inspired by many.

It started with Charley Holt, senior vice president of marketing, who aided us in creating the "Who We Are"; kudos to a true gentleman with a way with words and a big heart. And to Mindy Drucker, vice president of communications (and Mitchell's sister-in-law), for managing all the moving parts in bringing a project of a lifetime like this together.

To Kate Sennert, writer extraordinaire, who traveled to North Carolina to get to know us and this work/place we call home. And to first-class actress, producer, and advocate Judith Light, for her moving foreword, and for supporting our goal of comfort for everyone.

To our corporate chef, Sean Robinson, for sharing his incredible recipes and gracefully and graciously preparing them to be photographed for the tasting menu. And to photographers Sally Fanjoy and James Labrenz, who have provided us with a rich visual history from near day one. To Kim Draughn, amazing director of our day care for fifteen years, and her wonderful staff. And to working moms like Cheri Merritt, who inspired us to start a day care.

To the unflappable Dan Swift and Wendy Woods, for keeping us on track. And to Charley Holt's marketing department, always ready to help: Cindy Taylor, Jim Morgan, Thomas Pfaff, John Gray, and especially Leigh Anne Burke, for her detective-like ability to find photos from so long ago. And to Eloise Goldman, vice president of public relations and special events, for bringing us wonderful press that gives a picture of the company "from the outside looking in."

To our many key executives, including senior vice presidents John Bounous, CFO, friend and protector; Garrett Barr, manufacturing and procurement, a mensch with an engaging smile who embraced what some call the "unglamorous" side of the business; and Ken Hipp, retail stores, merchandising, and administration, at thirty-five our youngest SVP, who for thirteen years has handled every task we give him with intelligence and grace.

And to all our vital team members, including: Steve Bruton, director of administration; Laura Chapman, director of upholstery design; Katherine French, national sales manager; Dan Gauthreaux, vice president of human resources; Richard Gold, vice president of training information; Marjorie Hall, director of customer services; Melissa Hernandez, director of accessories, rugs & lighting; Ed Kuester, national contract account director; Reed Krosnick, plant manager; Paula Krosnick, PD coordinator; Matt Langford, director of stores; Bill Lattimore, director of sourcing; Carl Marmion, director of case goods design; Ryan Obermiller, director of store development; Mike Pennell, vice president of manufacturing; Angela Sherrill, general counsel; Leslie Stoll, fashion director; Matt Wilder, design associate; Customer Care, headed by Christina Leis; and IT, led by Kim Clay; Visual team—Brent Sheffield, Judson Vann, Brandon Bateman. Regional account managers (RAMS) Cathy Carey, Sean Gillespie, Rob Jensen, Hank Patterson, Stephanie Poliakoff, Karen Sisler. Licensed Signature Store partners: Ann Arbor – Susan Monroe; Dallas, Nashville, Atlanta, Plano – Ben Collins, Scott Touchstone, Travis Matthews; Boston, Natick – Steve Elbaz, Andrew Terrat, Greg Sweeney; Mexico – Jorge Barrantes, Mauricio Barrantes, Enrique Mestre; Puerto Rico – Blanquita Gonzalez, Alberto Escudero; Toronto – Rene, Ken, and Andrew Metrick. Corporate Signature Store managers: Tisha Biggs, Michael Cantwell, Page Collins, Casey Covault, Paul Eisenman, Lisa Katchadurian, Ryan Roberts, Ryan Rottum, Michelle Zigelman. And to our first employees, including Roger Dyson, Clifford Stafford, John Ramsey, Sandra Warren, Rick Ashley, Wayne Lowman, Clara Bostian, Michael Elder, Larry Dyson, Wayne Chapman, Wes Earp, Kim Payne, Melissa Childers, Gina Petersen, Penny Icenhour, Anita Davis, Pam Allen, Charles Sipe, Kim Clay, Angela Bolick, Darin Bolick, David Hollar, Matthew Elder, and Tracy Keever.

To Peter Petrillo, Eric Norfleet, and Andrew Thompson of Wafra Partners, who believed in our vision and invested in it. To Andrew Moser and Marc Price of Salus Capital Partners, our primary lenders, who made our dreams easier to achieve. To real estate partners Robert Futterman and Jeremy Ezra of Robert K. Futterman & Associates,

for helping us build a collection of stores in the most prestigious and convenient shopping areas.

To our many wonderful longtime customers with beautiful stores across the country and the world. To our growing team of design associates (our front line). And to every customer who has honored us by taking our furniture home.

Thanks to the great team at Assouline: Martine and Prosper Assouline; editorial director Esther Kremer, editor Nadia Bennet, book designer Cécilia Maurin, art director Camille Dubois, and photo editor Jacqueline Mermea.

With love to our families and friends, who have been so supportive of us. And to Brent Childers, executive director of Faith in America and dear friend; we couldn't accomplish what we do in the advocacy world without him. And to Lulu, beloved company mascot whose spirit lives on. It's great to be twenty-five years young. Now on to the next twenty-five.

Credits